MASTERPIECES OF CHINESE EXPORT PORCELAIN

Masterpieces of
Chinese Export Porcelain

from the Mottahedeh Collection
in the Virginia Museum

David Howard and John Ayers

SOTHEBY PARKE BERNET

First published 1980 for
Sotheby Parke Bernet Publications by
Philip Wilson Publishers Limited
Russell Chambers
Covent Garden
London WC2

and

Biblio Distribution Centre
81 Adams Drive
Totowa
New Jersey 07512

ISBN 0 85667 083 9 (Hardback)
ISBN 0 85667 085 5 (Paperback)

Printed in Great Britain by Jolly & Barber Ltd, Rugby
Bound by J. M. Dent & Sons (Letchworth) Ltd

Contents

The analysis below relates to the entire Mottahedeh Collection. *The bracketed numerals after each section indicate the collection numbers of the objects within it. Headings which are preceded by page numbers refer to those pieces discussed and illustrated in this book.*

THE PRINCIPAL PORCELAIN STYLES

THE WESTERN SUBJECTS OF DECORATION ON PORCELAIN

Introduction

Chinese export porcelain has, until recently, been neglected. Since the early nineteenth century much of this ware either lingered in cupboards, long uncleared, or was, indeed, in everyday use by the families for whom it was made. However, the last fifty years have brought new consciousness and knowledge of a subject that had been, until then, a mere addendum to the story of Western decorative art.

Perhaps for economic reasons, much of this family porcelain has been cleaned, re-appraised and, frequently, sold. While this is a source of regret to some, it has at least enabled the ware to become the focus of considerable academic attention. Museums, collectors, auctioneers and antique dealers have studied the porcelain and brought a fresh assessment of the intrinsic merits of the material. At the same time, the creation of a price structure has drawn more and more pieces out of obscurity, thus increasing the ever-widening body of evidence upon which comment may be passed.

This volume tells, in two broad chapters, the story of the export of Chinese porcelain over the last two thousand years and examines the historic, economic and artistic factors which contributed to its spectacular popularity in eighteenth-century Europe, and later in America. Porcelain had been made in China for some seven hundred years before Europe discovered its secrets about 1715. During the century which followed, it enjoyed its highest popularity, its finest quality and its greatest abundance, before succumbing, towards the close of the century, to the abuses brought about by mass-production against price targets and competition. The illustrations which follow provide a colourful insight into the mercantile world of the eighteenth century, and illuminate a tale whose subject is as rich decoratively as it is technically brilliant.

Over the last fifty years, Mr and Mrs Mottahedeh of New York succeeded in bringing together a matchless collection of this ware, which in its range and depth was able to furnish almost all the eight hundred illustrations for the book *China for the West*, published in two volumes by Sotheby Parke Bernet in 1978. Rafi Mottahedeh died during the week that this book was published, but not before he had seen and read what their collection had made possible. Mildred Mottahedeh has now placed the collection on loan to the Virginia Museum where, for the first time, its full range can be appreciated. This slimmer volume is intended to serve as an introduction to the story of export porcelain and the Mottahedeh Collection, and illustrates some fifty of its most beautiful pieces.

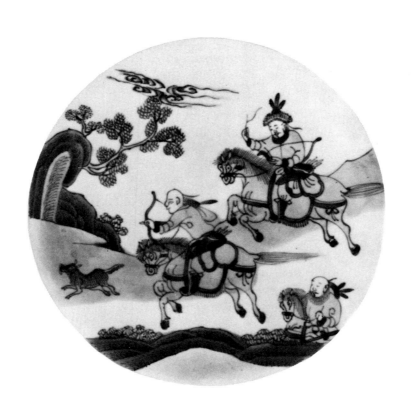

1 The growth of the porcelain trade and its principal styles

The trade in Chinese pottery is an ancient one, and appears first to have reached a significant level in the early centuries of our era. Exports were then directed to South-East, Southern and Western Asia and Japan, building up gradually over the centuries, and only at a comparatively late date spread to lands beyond the Eastern Mediterranean. Consequently it will be a striking thought to some that in what we know as the 'Middle Ages', large areas of the world were already aware of the Chinese potters' superior achievements and sought eagerly after their wares. The export wares were largely mass-produced goods intended for sale in exchange for raw materials and luxuries the Chinese could not obtain at home. Varying in quality from fine to ordinary, they reflect a major investment of industry, adaptability and skill: at the highest they were of a refinement acceptable to princes, and at the lowest they provided rice-bowls for peasants.

The situation as regards the later porcelains made for the West with which we are concerned in this volume is not very dissimilar. For the most part lacking in any exalted aesthetic pretensions, they display often very high technical standards and pursue excellence within well-calculated limits. Material and glaze are generally good and so is the shaping of the wares, a major difference however being the effort now expended on their painting which placed a high premium on subject-matter. This is especially true of the large class of porcelains that were produced according to Western specification and among which novelty, individuality and surprise were to become the order of the day. There are some of course to whom any allusions of a literary, historical or sentimental sort in art are liable to appear trivial or even perverse, and assuredly these porcelains are not for them – notwithstanding the fact that our ancestors in the eighteenth and nineteenth centuries, who displayed an insatiable appetite for such things, clearly thought otherwise. Most people today, however, respond gladly to their cheerful attractions, relishing their variety and delighting in the sheer profusion of themes that appeal to our sense of history; and the fact that the unfamiliarity of these to the Chinese painters resulted in frequent curious improvisations and miscomprehensions only heightens the all-pervading and generally pleasurable sense of contrast.

For in all that concerns this strange commerce with far-off China we meet with the most piquant confrontations. The sense of contact over great distances is a constant source of fascination, and we are continually made aware of the vast mercantile effort by which these fragile wares were first produced and then transported. The drive to the Indies through which cargoes of silk, porcelain and tea were finally in the sixteenth century brought to Europe by the immensely long route round the Cape gave the trade a further dimension; and it is even arguable that this marks some kind of turning-point in modern world history, linking as it did the remotest centres of power at that time. Yet for the Chinese merchant it seems unlikely that this new trade at first posed any very novel problems: for it was after all no more than the extension of an ancient maritime enterprise in which Indians, Arabs, Chinese and others had participated for well over a thousand years.

As we know from Herodotus and other writers, the ancient Greeks were aware, however distantly, of the existence of China, and in the time of Rome (which the Chinese knew and recorded as 'Ta Tsin') trading contact between the two Empires was firmly established. This trade followed two principal routes, one running overland from China across the Central Asian deserts to lands south of the Caspian, the other by sea skirting Southern Asia to the Persian Gulf, or continuing to Egypt by way of the Red Sea. The main commodity upholding this unlikely link was silk: a Chinese monopoly manufacture on which the Romans relied more and more heavily as in time it came to be worn throughout the Empire and among most classes of society.

Throughout history the land route has played a crucial role in the interchange of goods and ideas between East and West; and despite the legend of China's isolation there can be few arts or industries of that country which have not at one time or another absorbed a significant influence from lands to the West. But on account of the formidable terrain and immense length of the journey such traffic in goods has always been vulnerable and subject to interruption of many kinds in the turbulent principalities through which it passed. The Chinese generally took only a limited part in this commerce and but rarely occupied themselves with making the routes secure. One such occasion was in 128 BC, when the powerful Emperor Wu Ti of the Han dynasty sent his envoy Chang Ch'ien to the Hellenistic lands of Sogdia and Bactria. His mission – in which he was largely unsuccessful – was to enlist allies against the Hsiung-nu or Huns of Mongolia who constantly threatened the Chinese frontier. According to legend it was he who brought to China its first knowledge of the vine and the grape. By the end of that century Chinese penetration into Western Asia lent further support to a trade that carried ever more strongly to the Eastern shores of the Mediterranean.

In addition to silk the Romans procured from China such delicacies as rhubarb and cinnamon. It is not clear what the Chinese sought from them in return: Syrian glass perhaps, and it is known that exorbitant quantities of silver and gold were paid out. In all probability however little of this reached China and it will have been absorbed by successive middlemen along the route, each involved in some branch or other of the highly lucrative trade. As time passed the land routes declined while those by sea grew in importance, for the latter proved increasingly the more reliable and less subject to political manipulation, extortion and banditry. Here it was the Indian and Arab rather than the Chinese merchants who controlled the trade along most of its length, and while the Romans themselves took an increasing part in the sea voyages it was rare for them to sail beyond India.

Those centuries which saw the decline of Rome on the one hand and the collapse of the Han Empire on the other were not conducive to extended relationships by either route. Certainly where Europe is concerned, we can say that virtually all knowledge of the East had been lost by the early Middle Ages and that 'the Orient' had come to mean merely the land of the Saracen. Even Byzantium (Fu-lin), which inherited the mantle of Rome in the eastern Mediterranean, and is reported to have exchanged occasional 'missions' with China, seems to have shared scarcely at all in the cultural interchange which grew up between the East and Islam – for united partly by conquest and partly by religion, and stretching from Cairo to the Caspian, this conglomeration of states now barred the way between China and the West equally by land and by sea.

Throughout this period – although a few pieces of Han dynasty date

(206 BC–AD 220) have come to light in South-East Asia – there is no reason to suppose that Chinese pottery was at any time a significant article of export. But pottery jars were no doubt used to carry the various foods and liquids that ships customarily carried on their longer journeys, and it was in this way perhaps that by the T'ang period (seventh to tenth centuries) the exceptional qualities of the Chinese wares began to be widely known. They thus came to be in demand in far-distant markets, and at the sites of trading-posts all the way from Java to India, Ceylon, the Persian Gulf, Mesopotamia and Egypt, archaeology has begun to reveal further evidence of this traffic.

The reverse side of this expanding and enriching Asian trade, in which it must be said pottery occupied as yet only rather a minor place, is revealed by the excavation of tombs in T'ang China itself. For alongside the much-admired pottery horses and camels which were the motive power of the land trade and the dignified figures placed there to attend on the deceased, are found also models of people from central Asia, Persians, Armenians, Indians and those of a number of other races that supplied retainers for prominent Chinese households, or were for other reasons frequent visitors to the streets of China's major cities. Among the surviving evidence of the prosperity and influence the country then enjoyed is much that points to the extraordinarily international character of its society, and for a century or two it seems China opened her doors to foreigners and their beliefs and arts more completely than at any time before or since. It was at this time too that there came to the cities of the Near East – as excavations at Siraf, Samarra, Nineveh and elsewhere have shown – the uniquely durable glazed stoneware pottery of China and by the ninth century, also, its miraculously translucent porcelain.

There is no doubt of the attraction felt in lands far from China for porcelains as they became increasingly an article of trade; and something of the excitement they aroused may be recaptured even today by the archaeologist as the brightly-glazed ware emerges from a trench in a swampy tropical inlet or cemetery site. Like glass, but perhaps even more versatile in its uses, porcelain was seen to have about it something of the miraculous: it was a man-made material with the qualities of a rare natural substance and yet capable of being shaped at will. Its invention in China was no sudden discovery, but the result of long and gradual evolution. One essential element in this had been the ability to fire pottery to high temperatures, which enabled the Chinese in quite early times to make stoneware – hard, vitreous and impervious to liquids; this was largely owing to the superior construction of their kilns. At the same time the development of suitably tough glazes which would not disintegrate or peel off with long usage brought a further gain through its potential variation of surface quality, which in inspired hands opened the way to new artistic levels. However, it was through the use of certain refined white clays (*kaolin*) and mineral rocks (*petuntse*, or 'little white bricks') that Chinese potters in T'ang times carried the achievement to its ultimate stage, eventually creating a fine homogeneous substance that is both white and gleamingly translucent. This was true porcelain as it is understood in the West – the ideal to which many European potters aspired, although too often with indifferent success, some eight or nine hundred years later.

The early history of porcelain-making in China is still far from clear, but it seems likely that the first wares to merit this name were made in the north of China. Notable more for their vitrified whiteness than for any marked translucency, the brightly-glazed T'ang porcelains have nevertheless resisted decay in burial in a way not shared

by most other white pottery of the period. Perfected by the ninth century, and soon exported – for fragments found in Mesopotamia and in other contexts are apparently of this date – they are the ancestors firstly of the celebrated creamy-white Ting ware of the Sung period made in north-east China, and to an as yet undetermined extent also of the wares of Ching-tê-chên in the south.

The Sung period (960–1279) is often characterized as one of closed frontiers and cultural withdrawal, yet while this may well apply to the land route it is far from true of her trading by sea. The evidence shows on the contrary that the export of ceramics was sizeably expanded, especially under the 'Southern Sung' when the court was moved south to Hangchow. No ware more fully characterizes the taste of this time than the so-called celadon ware of Lung-ch'üan, with its rich and lustrous bluish- to grey-green glaze, which was made at a large number of kilns in this region of the easterly province of Chekiang. Another important place of porcelain manufacture at this time was the area around Ching-tê-chên in the province of Kiangsi, further inland and near to the middle reaches of the Yang-tze. This was to be the great centre of the industry of later times; and already it made the purest of white porcelains, although generally covered with a glaze of pale bluish-green hue and resembling a brilliant sky, which is known to ceramic specialists as *ying-ch'ing* or 'shadowy blue'. But while these were widely used in China proper, so far as export was concerned they did not yet rival in popularity the celadon wares of Lung-ch'üan.

By the thirteenth century these products, together with lesser-quality versions made at the many new kilns that sprang up within reach of the coastal ports of Kuangtung and Fukien provinces, were being shipped in vast quantities to the markets of Southern Asia, and thence onwards to Arabia and the Near East. Political events however once more took a hand as a new power arose in Asia: that of the Mongols. Their conquests were perhaps the most destructive and surely the most terrible in history, extending across Asia to Russia and the lands of the Near East where they went far to extinguish the old Islamic civilization. In China the brunt of their assault was borne by the Jurchen Tartars who had occupied the north in the preceding century, but by 1280 all resistance had ceased both there and in the south. One significant result of Mongol rule was a destruction of national boundaries and spheres of power which reflected directly on the possibilities of trade and communication. Only at such a time could Marco Polo have made his remarkable journeys, or have been enrolled in China as an administrative official; no one before him had been in a position to write such an account of the Chinese Empire, its people and their customs.

It was in these circumstances that the Chinese porcelain manufacturers took up and adapted the Near Eastern style of painting their wares with graphic designs, using a cobalt-blue pigment that was apparently imported from Persia. The technique they evolved was the basis of the ever-popular blue-and-white style, which would seem to have originated early in the fourteenth century. Within a century, acceptance of this change had overwhelmed all rivals and established the pre-eminence of the Ching-tê-chên factories both in the home market and abroad, setting the very different pattern of ceramic production that prevailed throughout the restored Ming dynasty (1368–1644). From the outset this period witnessed a very substantial trade in blue-and-white porcelain with the Near East where much has survived to modern times, notably in such famous collections as those of the shrine of Abbas II at Ardebil in Persia, and the Topkapu Sarayi Palace of the Sultans in Istanbul. This increase in

trade was no doubt fostered by the rare, and no more than temporary, participation of the Chinese themselves who undertook seven long voyages westward under Admiral Cheng Ho between the years 1407–33, carrying them as far as Zanzibar.

Meanwhile, occasional specimens of porcelain had now penetrated by one means or another to the closed world of Europe where they may well have served to heighten a growing mood of curiosity. The century of the Mongol hegemony in Asia had contributed to the overthrow of traditional boundaries and disturbed many settled notions of geography and navigation in the West. The gradual circulation of Marco Polo's *Il Milione* had detailed the character of an hitherto unknown half of the globe, and opened up prospects of quite extraordinary fascination and promise to the adventurous. Mercantile Europe was at last stirring and its sea-power and trade were on the increase. Venice and Genoa vied ever more strenuously with one another in a commerce that received fresh stimulus from Near Eastern contacts – despite the troubled background of the Crusades – and already extended by way of Russia into Northern Asia. That Polo's book should have been dictated in a Genoese jail is entirely symptomatic of this rivalry in endeavour. Motivated also by the search for the source of the immensely profitable trade in spices, this thrusting spirit was to lead outwards from the Mediterranean lands to the exploration of the Atlantic and Indian Oceans, and even to the crossing of the Pacific. It was in the sure conviction that the world was round – however much larger in fact than he supposed – that the Genoese Columbus set out westward in search of the Indies in 1492; while the great African landmass, for long visited by the Portuguese, was at last rounded in 1498 by da Gama who boldly sailed on to the coast of India, returning to Lisbon with a fine cargo of pepper.

And so in the Far East the sixteenth century was destined to favour the Portuguese. The Muslim Arabs who had for so long dominated the trade there were no match for their opponents' superior armament and their power was swiftly destroyed. The Portuguese then established themselves at a succession of key points from Ormuz (which controlled the Persian Gulf) in 1514 and Goa (on the Indian coast) before 1511 to Malacca, which they seized in that year. Malacca was the main junction for the Indies spice trade, and also the limit reached by the Chinese junks which came south with their exchange cargoes of porcelain and silk. From here the Portuguese engaged increasingly in the most profitable commerce of Asia which they had wrestled from the Arabs, reserving no more than a necessary share of their activities for the long journey to the West. Their first official approach (in 1517) to the Chinese at Canton which they had visited three years earlier met with a positive rebuff and it was not until 1557 that they were allowed to settle on the promontory of Macao, which was to become their permanent headquarters.

Primacy in the seventeenth-century trade of the Far East belonged in turn to the Dutch, whose maritime power rose with surprising speed at this time following the conclusion of their bitter and successful struggle for independence from Spanish rule over the Netherlands. It was a conflict no less of Protestant against Catholic, and one in which significantly the piratical Dutch 'beggars of the sea' had played a keen part. The Pope's dictat allotting the Western seas to Spain as their sphere of influence and the East to Portugal won scant respect in this quarter, and both Dutch and English alike were now eager to humble this presumption and secure for themselves a share of the distant spoils. When therefore in 1604 the Portuguese carrack 'Catarina' was taken by the Dutch off the coast of Malaya there was much rejoicing in Amsterdam,

and interest was redoubled by the sale at auction there of her cargo, which included 'an untold mass of porcelain of all kinds', its content being estimated by Volker to have been at least 100,000 pieces.

In the following year the spice island of Amboyna was seized, and the Dutch East India Company which had been formed two years before soon established its head-quarters at Batavia on the north coast of Java, ousting in a short while the Portuguese from all their principal centres of influence with the exception of Macao. From Japan, Siam and Burma to Bengal, Ceylon and Persia the Company set up a network of trading posts through which this extensive entrepôt trade could be conducted, and while she never succeeded in securing a foothold in China proper, her requirements were for the time being amply served by her settlements in the Pescadores and (from 1624) on Formosa, where large stocks of porcelain were accumulated through the merchants who came there from China. From here the ships sailed south to Batavia with the prevailing winds in winter, as did the Chinese frequently themselves, returning with other cargoes in the summer. Even at this time, however, porcelain occupied but a small fraction of the trade. Indeed, its greatest merit in the eyes of ships' captains was its value as ballast, for it could be stowed low in the holds without risk of spoiling or of contaminating other goods and was excellent for trimming the vessel's cargo.

It is with blue-and-white porcelains of a kind transmitted to Europe by the Portuguese in the sixteenth century that the record presented in this collection begins. These examples represent types that were only rarely designed for that market although the influence of Islamic taste in shape or design is quite often noticeable – understandably enough, for that trade it will be remembered was already one of long standing and the Chinese were well accustomed in consequence to foreign commissions: for example, when these involved painted inscriptions in Arabic (no 2). At first decoration was based on the classic early Ming tradition with much basic use of floral scrollwork or sprays in bands or in panels, and fabulous creatures such as the dragon and phoenix. But as the century progressed the range of subject-matter was diversified to include more figure scenes and other motives from nature. Especially frequent are the carp, the deer, the crane and many types of insects and plants, all generally reflecting the mythology of popular Taoism with its recurrent pursuit of a long, fruitful and well-regulated life, and conveyed through a web of symbolism that wholly escaped their recipients in the West: a part of that jealously-guarded China which the visiting foreigner could not hope to penetrate. Well-made and relatively robust, these porcelains consist predominantly of useful dishes, plates and bowls in several sizes together with various jars, and flasks, bottles and ewers for the storing and serving of liquids. They are at times somewhat over-decorated by Chinese standards and not always neatly executed, but their uninhibited vigour is nevertheless thoroughly endearing. By the end of the century many, perhaps the majority of wares are adapted in shape to Near Eastern or Western requirements, but a mere handful bear decoration dictated by the Portuguese. They include such rarities as certain ewers bearing the 'armillary sphere' device of King Manuel I, which was no doubt copied from a coin or medal; while a few bowls or bottles are known inscribed with Portuguese names, together with the Western dates 1541 or 1552. To the same initiative may be ascribed the rather later piece carrying the arms of Leon and Castile – those of Portugal's spiritual ally if sometime rival, the kingdom of Spain (no 8), and also a covered jar of the mid seventeenth century bearing a Christian cross; while it

seems likely that late pharmacy jars of Mediterranean shape were also ordered through the Portuguese.

When the Dutch came they brought to the porcelain side of the trade a somewhat brisker and more practical approach, dictated no doubt by the avid demand that now existed for this commodity in the West. Imports of the so-called *kraakporselein* or 'carrack porcelain' continued for a while largely unchanged, but they were always trying to improve standards, and about 1635–40 brought to Europe examples of the so-called 'Transitional ware': porcelains of the finest material and glaze, and in painting also reaching a new level of accomplishment. In addition to this, through their intermediaries they succeeded in persuading the Ching-tê-chên potters to produce a range of specified shapes based on wooden samples, which were moreover 'painted with all kinds of Chinese figures'. The report of these in the Batavia records specifically names such things as mustard-pots and salt-cellars, while others of this kind include the familiar beer jugs and tankards, and the 'beaker' and 'rollwagon' cylindrical vases. Many of these together with their decoration of Chinese figures, landscapes, animals and plants were closely copied at the rising potteries of Delft, whence in their turn wares were later in the century sent to the East once again to be copied. For the period down to 1657 more than one hundred and fifty different forms, not a few being of European derivation, are noted by Volker as having been included in home-bound cargoes from China; and during these fifty-three years some three million pieces in all were shipped to Holland by the Company.

The year 1657 has significance as that in which the Dutch trade with the Chinese mainland came to a standstill. Difficulties had been growing since 1644 when the failing Ming dynasty succumbed to the Manchus, and by this time all traffic with the mainland was effectively cut off by the rebel Coxinga. The Dutch turned instead to Japan, further to the north, where in 1641 they had been permitted to establish their 'factory' on Deshima Island in the bay of Nagasaki with (apart from the Chinese) a trading monopoly. From here they could obtain supplies of porcelain from the factories of Arita, via the port of Imari. In 1659 they shipped their first significant cargoes of Japanese porcelain, comprising mainly blue-and-white wares for the Arabian and Indian markets, and a smaller quantity for Europe; and for the next twenty-five years these factories underwent a significant expansion to meet the demands of a flourishing trade. Many of the shapes of the porcelains were again to Dutch specification, but their painting represents more often than not a parody of the former Chinese styles: it is rather in the enamelled wares of the so-called 'Kakiemon' palette that the finer and more economical Japanese taste reveals itself in compositions that may well have disturbed their first recipients in Europe by their bold asymmetry. In the eighteenth century discerning collectors still recognized these as the finest porcelains they had seen: in their rich and well-balanced colouring and the originality and fine craftsmanship of their painting they stood alone, and they were carefully copied in the European factories, notably at Meissen, St Cloud and Venice, at Chelsea and at Bow. More common than these aristocrats were the so-called 'Imari' wares, in which the sometimes muddy, purplish underglaze blue is allied with enamels more akin to the Chinese *famille verte*: these seem only to have emerged fully during the last decade of the seventeenth century (no 108). By this time however – if Volker's reading of the Company records is correct – the trading of Japanese porcelain to Europe had been abandoned by the Company which found it too difficult and unprofitable. Such large quantities of Japanese wares remaining in Europe, however,

can be dated later than this so that we must assume they in future travelled either as the private cargo of Company officers, or by some other route such as via the Chinese, whose trade with Japan seems to have continued unabated (no 100).

In several respects the Japanese left an important mark on the porcelain trade. Above all perhaps they had introduced to Europe the authentic note of their own very different style of design, and in this respect the 'Kakiemon style' wares ('ancien première qualité coloriée du Japon', as they were called by Julliot in 1771) remained highly influential; what is more, they made 'coloured' wares familiar in Europe whereas they had previously been rare. They also took a stage further the production of wares based on Dutch models, especially as regards shape, and they set a fresh emphasis too on the porcelain figure: their models of animals (tigers, lions, birds) and of men and women actors so reminiscent of early woodcut prints being in advance of what was later done in China. And last but not least, they filled for a quarter of a century what might otherwise have been a deep void following the collapse of the trade with China.

In Europe this period also saw some interesting developments in the uses to which porcelains were put. In former times their very rarity had made them fit subjects for mounting in silver, when not in use to be stored away in the treasury or *kunstkammer*; now they were plentiful enough at least in Holland to be collected in quantity, and as prints and still-life paintings show they were ranged there on wall-brackets, mantel-pieces and stands, or eventually in cabinets, while in due course the *garniture de cheminée* (a matched set of perhaps five vases of various shapes) appeared. Porcelain had indeed arrived as a medium of interior decoration. When in 1689 Queen Mary II of England, wife of William of Orange, returned from Holland to London on his assumption of the English throne, her palaces both at Hampton Court and at Kensington soon had galleries or rooms decked out in such a way – as we learn from an inventory of the latter made after her early death in 1694 and, in the former case, from Daniel Defoe and from Celia Fiennes who saw there the special 'porcelain closetts' which she had constructed. At Berlin, in the Charlottenburg Palace King Frederick I of Prussia had installed by 1706 a splendid, and now recently restored, room in which porcelain adorned the mirrored walls literally from floor to ceiling; while at Dresden, Augustus the Strong, Elector of Saxony and King of Poland, was to assemble the greatest porcelain collection of them all numbering some ten thousand pieces, and to devote the 'Japanese Palace' to their display together with the products of his own newly-founded Meissen factory. Meissen was the earliest manufacture in Europe of true 'hard-paste' porcelain of the oriental kind, and for many years stylistic acknow-ledgment was made in its wares of the powerful debt owing to China and Japan.

For this reason it was all the more powerful an agent in disseminating their influence among the other factories which followed. The entire Dresden collection was recorded in a running inventory begun in 1721 and probably terminating with the king's death in 1733, only parts of which unfortunately survive; while each piece was engraved with a number and a device denoting its type. Several of these inscribed pieces appear in this collection.

It was in 1683, Chinese sources tell us, that the ruined imperial porcelain factory at Ching-tê-chên was rebuilt under a new directorship, and it cannot have been long thereafter that the Chinese set about recreating their profitable export trade. Standards were high, and the very great quantities of porcelain sent to the West during the late seventeenth and early eighteenth centuries were of a quality that fully justifies the

fame of 'K'ang Hsi blue-and-white' (no 18), a vogue for which swept European, and especially Dutch, society at this period. The same ware was also to undergo a marked revival of favour in mid to late Victorian times, and in Holland it was still fashionable well into the nineteenth century to mount the ware in silver for use at table. The careful preparation of the material, glaze and pigments are described at some length for us by that rare eye-witness Pére d'Entrecolles, whose unique early eighteenth-century *Letters* detail the highly-developed system of mass-production which was employed even in the painting of the designs. He was aware of and commented on the commissions for Western designs which it seems were in demand not only for export: 'The mandarins,' he remarks, 'who know the genius of Europeans for inventions often ask me to have brought from Europe novel and curious designs so that they may present to the Emperor something unique'; and elsewhere he notes also the occasional production of wares on which Christian designs were painted.

Ching-tê-chên, however, was not the only centre where porcelain was made for the West at this time, for at Tê-hua in the coastal province of Fukien was made the so-called *blanc-de-Chine* ware which, with its pure, creamy-white translucency, is in some ways an even finer material. In consequence it was generally not decorated but left 'in the white', although gilding or enamelled designs were sometimes added to it in Europe where clients found it too plain. Table wares were made here, but these were not always well suited to Western use and to a certain extent no doubt, like the numerous figure models, were treated as decorative novelties. Representing in the first place unfamiliar Chinese deities, these last lent an agreeably exotic air to the furnishing of shelves and overmantels and were a suitable complement to the lacquer furniture and silk hangings from the East which were then in fashion. About the end of the seventeenth century there also appeared a variety of models and groups in which Europeans are depicted in more or less crude and child-like caricature. These toy-like commissions which are numerous at Dresden seem largely attributable to the activities of the Dutch, who had no doubt reverted to trading at ports such as Ch'üan-chou or Amoy along this coast.

Dutch enterprise, too, was probably the leading factor in the commissioning of the more novel and interesting blue-and-white export designs that began to emerge from Ching-tê-chên at this important turning-point in the history of the trade, and which opened up new fields in their use of Western subjects. The 'Rotterdam riot' wares of *c* 1690–95, the van Frytom style landscape plates, and the series of colourful enamelled or partly-enamelled wares bearing the arms of the Dutch provinces and cities (no 95), all lend support to this conclusion which is further reinforced by the addition to the set of the arms of England and France, titled however in Dutch spelling. A succession of plates and jars, the designs for which prove to have been borrowed from Parisian fashion prints of the day, may likewise have been ordered through Amsterdam, for the same prints were copied also in the decoration of Dutch delftware. More enterprising still was their apparent use to commission some unusual figure models enamelled in the *famille verte* style.

Polychrome painted designs play an essential role in the story of the eighteenth-century wares. Coloured enamels had been a feature of much Ming porcelain but not of its ordinary export wares, presumably because of the greater expense. Among the few early exceptions might be mentioned those preserved in Schloss Ambras near Innsbruck, or the two von Manderscheidt cups mounted in silver which are known by inscription to have been brought to Germany from Turkey in 1583 (one of which is

now in the Victoria & Albert Museum). By the second half of the seventeenth century however, export wares with enamels supplementing designs partially done in underglaze blue had become relatively numerous; and these are the obvious precursors of the celebrated *famille verte* style, so characteristic of the reign of K'ang Hsi (1662–1722). The several shades of green enamel, like the other colours which went to make up the palette – blue, yellow, and violet- or purplish-brown together with black – were thoroughly glassy and translucent, the exception being the prevalent iron-oxide red, which is dense even when thinly applied. This palette remained remarkably consistent down to the early 1720s, although not all the colours were invariably used, and sometimes underglaze blue was preferred to its enamel equivalent. Another development is that known as *famille verte* enamelling 'on the biscuit', with the colours applied like glazes to an unglazed porcelain body, and here the richness of colour attained is especially striking: it was often preferred for figures.

Yet another alternative style for export wares of the period *c* 1705–30 is that commonly known as 'Chinese Imari'. This clearly derived from the Japanese Imari ware and may well have originated in a specific preference of the Dutch: it combines in its simpler form designs painted in underglaze blue with red enamel enhanced with gold. In these three decorative styles of the K'ang Hsi period – blue-and-white, *famille verte* and 'Chinese Imari' – a great profusion of wares were produced and the most prolific stage of the trade was now in sight. As designs derived from Europe became more frequent so did Western shapes for the porcelain, and much was copied from silver, pewter or glass (nos 119, 125). Examples of such borrowing are the ewers or wall-fountains with basin for ablutions, monteith coolers for wine-glasses, and barber's bowls. Now began also the fashion for armorial wares, generally in the form of services for the table on which the family coats-of-arms were copied by the Chinese craftsmen, working from a drawing or bookplate sent to China for the purpose. The earliest such ware made for the English market in fact exists only in the shape of some plant-pots which were made for the shipbuilder Sir Henry Johnson about 1693–98. No more than fifty or so services for this market are known from the years before 1720, the greater part of these being made post-1715. But it is estimated that more than four thousand services were produced for the English market alone between 1700 and 1820.

Yet another significant aspect of the trade of this time was the growing importation of tea, with the very considerable consequences for social habits and manners that this was to entail. Among the earliest ceramic wares for tea to reach Europe were the teapots of unglazed stoneware which came from I-hsing in the easterly province of Kiangsu. They were imported (probably with the tea) in the seventeenth century and some had reached Holland even before 1660, the year in which the diarist Samuel Pepys sent for his first cup of this 'China drinke'. Early in the next century the pots were still small in size, each in fact holding an individual serving, and it was not until the 1770s or so that the larger 'can' shapes based on English silver models make their appearance. The occasional outsize example must be a punch-pot. Even in the 1720s the assemblage of wares used at tea was still somewhat miscellaneous as can be seen from contemporary English or Dutch genre paintings, which often show a silver teapot and tea-caddy and perhaps also a kettle, as well as porcelain cups and saucers. The popularity of the complete porcelain service with teapot and stand, slop-bowl, spoon-trays etc was still to come and belongs more to the age of the *famille rose*, when wares of an almost 'eggshell' thinness were produced, decorated with the most elegant

designs. Even at this date the cup with handle was not intended for tea but for coffee. The porcelain dinner-service, too, was some time in reaching its full development. Its origins lay in silver and pewter which from the outset inspired its design, and in the early eighteenth century it emerges as a series of matching plates and dishes accompanied frequently by salts, candlesticks and mugs and sometimes also by water-flasks or ewers with basins, all based on metal forms. The sauce-boat appears little before 1720, and the characteristic tureen, although found occasionally in *famille verte*, is not a regular part of the service before the 1730s.

The date of introduction of the *famille rose* style enamels in China is still under debate. From the evidence of the Lambert, Visconti and other armorial wares it is clear that the rose-pink and opaque white pigments were already in use by 1722, but wares painted in the full palette are few until later in the decade. The pretty colouring (with new, shaded tints made possible by mixing with white (nos 130, 137, 144, 149)) lent itself particularly to the floral subjects and scenes of women and children which decorate many of the finely-executed tea wares of the period, some of which bear the reign mark of Yung Chêng, 1723–35. These also show diapered or plain-coloured grounds that link them to the tea-services of Meissen and, a little later, of Sèvres, Chelsea and Worcester; while on some pieces, more simply, the designs are delicately drawn in black enamel and gold. The general lightness of touch displayed is altogether remarkable and reflects the unmatched quality of the contemporary wares made for the Court in the Imperial Factory. The Emperor Ch'ien Lung (1736–95), his celebrated successor, was a man of unusually eclectic tastes whose interest in curiosities from the West is among the stranger features of this time to find reflection in porcelain. For the Western market many tea- and dinner-services of a more routine kind were also produced in the *famille rose style*; but by this date the main interest has shifted to wares in which style was dictated by the Western patrons, whose diverse and often very exacting requirements must have presented the potters with a bewildering task. The decoration of these is based substantially on variations of the *famille rose* palette; and they make up the largest single theme of the present work.

The conditions of trade in which all this porcelain was ordered were rather different from those that had prevailed in the seventeenth century. The period immediately after 1683 when the Dutch returned again to Chinese waters is still somewhat obscure, but by the turn of the century we know that both French and English ships had traded at Canton with considerable success and within a decade, despite the initiative and enterprise of the Dutch, it was the reinforced English Company, with all the support it could now call upon from its possessions in India, that began to dominate the scene. Things had altered, however, to the extent that this relatively unrestricted trade no longer implied cut-throat competition to the point of war, and a steadily growing market in the various countries of Europe was met by the formation of several companies trading each according to its requirements: a fruitful state of affairs that reflects the shrewdest management on the part of the Chinese merchants themselves. The vast trade of the eighteenth century was based as before on tea and silk rather than on porcelain, a substantial proportion of which was traded privately by members of the companies. In England, imports of tea alone from China were to multiply forty times between 1723 and 1830, and it was this commodity above all that accounted for her preponderant role. Her factory or 'hong' established at Canton in 1715 was the first to be permitted to a foreign company, but it was successively joined by others until finally as many as a dozen were set up along the

waterfront. In addition to the Dutch, French and Portuguese, others to join prominently in the trade were the Danes (1731) and the Swedes (1732), also the Ostend Company under the patronage of the Emperor Charles VI, and the Spaniards, who continued to trade across the Pacific via their American colonies. In 1784, too, an American vessel, the *Empress of China* sailed from New York to Canton and successfully engaged in the trade. No 'American Company' was to be founded, but it was the first of many hundreds of voyages made in the following decades from these former British colonies, and marks the opening of a new chapter in this lengthy story.

II *The influence of Europe and Western subjects of decoration on porcelain 1720-1850*

The year 1720 in Europe, if any year must be so chosen, saw the early blossoming of much which was to typify the eighteenth century. In more than one country it finally brought the old century to a close and heralded a new era; while far away in the unified Kingdom of China, an area greater and more populous than Europe, the ageing Emperor K'ang Hsi had barely three years to live, although few in the West were even aware of his existence.

In 1720 Great Britain had yet to claim her place as the most powerful nation in Europe. The death of Queen Anne in 1714 and the troubled year of Jacobite invasion which followed were still green in the memory. The Hanoverian succession to the throne of England, which was to bring such lasting benefit to the nation, was too recent to be seen in perspective. As at many periods in European history it was the 'Balance of Power' that occupied the thoughts of the European rulers. The newly emerging Empire of Russia under its unpredictable but far-sighted Tzar Peter had created a new horizon for the European scene. The long war in the north had brought the final breaking of the Swedish power over much of Northern Europe ending with the Treaty of Fredericksborg in July 1720, and the confirmation of Denmark as the possessor of Schleswig and a nation of equal power in Scandinavia. Such settlements were a prerequisite to the century of trading and enrichment which was to follow.

In Northern Europe, too, the succession of Frederick William I to the throne of Prussia in 1713 at the age of twenty-four heralded the carefully-planned expansion of the military forces of that country into the army which was to be the ally of England under his son, Frederick the Great, in the Seven Years' War (1756–63) and later on the field of Waterloo. Nevertheless, when a British squadron had sailed into the Baltic in 1719 and Stanhope, the English Prime Minister, had travelled to Berlin to suggest that the finest army in Europe and the finest fleet should co-operate, Frederick judiciously decided not to support the English naval attack on Livonia, for he preferred to remain on friendly terms with the Russians.

By the close of the seventeenth century the sad decline in importance of the Kingdom of Poland had led to competition by rival claimants to the throne and the eventual crowning of Augustus II, Elector of Saxony, in Cracow in 1698. The northern war which terminated for Poland in the defensive alliance of Vienna in 1719 had been an unmitigated disaster for that country and Augustus, who ruled both jointly until his sudden death in 1733, is remembered more as the greatest of all collectors of porcelain and founder of the manufacture of European porcelain at Meissen, than for the rather inept rule of his country of Saxony and the difficult Kingdom of Poland.

In 1719 the Emperor Charles VI of Austria had been the other signatory of the Alliance of Vienna with King George I of England. It was only thirty-six years since the armies of Turkey had stood before the gates of Vienna but that age was forgotten. Instead the Hapsburg monarch was deeply involved in the question of the Austrian succession and establishment of the 'Pragmatic Sanction' – the succession of his daughter – which was recognized formally in Austria in 1720, in Hungary in 1722 and

in the Austrian Netherlands in 1724. The first guarantor of the Pragmatic Sanction was Philip V, King of Spain, who formed a bond with Charles over the establishment of the Ostend Company which both hoped would break the near monopoly of the Dutch and the English in the lucrative East Indian trade. This bond was not to last, but it was a first step in the very complex series of alliances which led in 1740 to the War of the Austrian Succession.

The Bourbon families of France and Spain, close in blood but dissimilar in character, were to experience very different fortunes in the eighteenth century. Philip V had married in 1714 his second wife, Elizabeth Farnese of Parma, whom the Parmesan agent Giulio Alberoni, the remarkable son of a gardener at Piacenza, had pointed out to him on the day of the previous queen's funeral. For the next five years Alberoni was to rise in Spanish favour until he was virtual ruler of the nation, encouraging Spanish claims in Europe and giving stimulus to Spanish-American trade. Such meteoric rises in fortune became possible for the commoner in the eighteenth century, with trade often providing the impetus.

In France the death of King Louis XIV in 1715 and the succession of his four-year-old great-grandson led to unexpectedly energetic government by the Regent, the Duc d'Orléans. But for the Treaty of Utrecht, the claim of Philip V as Louis XIV's direct descendant would have come before that of the Duc d'Orléans, and while the Duke naturally chose to ignore this Philip brooded on the injustice. Subsequently, this led to a brief war in 1719 and the invasion of Spain which had as a major consequence the dismissal of the capable Alberoni who, had he been vouch-safed a longer period of influence, might have made Spain the premier power of Europe. In 1724 Philip V and his Queen abdicated barely six weeks after the death of the Duc d'Orléans.

By 1720 the maritime power of Holland had declined greatly from the position she had enjoyed in the second half of the seventeenth century. Her possessions in the East Indies were relatively secure but she had to endure powerful neighbours who controlled the Spanish and Austrian Netherlands and it was not until 1789 that she finally expelled the Austrians, only to be occupied four years later by France. But in 1720 the Dutch were preoccupied by financial collapse in France under the Duc d'Orléans and his financial adviser, Law (see no 230), and also in England, where the South Sea Bubble had brought disgrace to many merchant families in London. The Dutch were not prepared to see their own hard-won trading advantages squandered through the speculative gambles which had swept France and Britain. It was a Scotsman, Colin Campbell, who, fleeing from his creditors in England, was first to find success in the Ostend Company and then to found the Swedish East India Company, turning Gothenburg from a fishing village into a European city of importance.

While Europe was aligning and realigning itself to meet the major wars of the century – the War of the Austrian Succession (1740–45) and the Seven Years' War (1756–63) – it was the prizes to be won by trade that pre-occupied the thoughts of a growing middle class of merchants who were able to sail beyond the horizons of Europe and bring back the products of the East (by then teas and silks, spices and lacquers, enamels and porcelain) to enrich the life of those who could afford them.

Even the greatest houses of the seventeenth century in Western Europe were poorly furnished in comparison with their counterparts a century later. The heavy oak furniture and darkly-painted walls or panelling, the areas of bare-tiled or timbered floors with occasional rugs and carpets and the cumbersome silver and pewter plate,

all displayed quality but were without great comfort or artistry. When however men saw the sumptuous decorative features of King Louis XIV's court, the brilliant mirrors and paintings, ormolu-mounted porcelains, bronzes, and new and finer forms of furniture set against finely-painted wallpapers a wider revolution in the decorative arts got under way. Well established by 1720, this continued to enhance and delight throughout the century as succeeding styles and ideas and new products became available to an increasingly prosperous Europe.

Prominent among the *objets d'art* of this era were wares for the table, and as the new dining-room with its specialized furnishings, tables, chairs and sideboards, wine-coolers, plate and porcelain became fashionable a new industry sprang up to supply such wares, co-ordinating the styles of furniture, silver and porcelain decoration into a harmonious scheme. Design was not limited in its application to particular materials, the silver monteith of 1680 becoming the Chinese porcelain monteith of 1700 and the slender, conical coffee-pots of 1730 being similarly translated by 1735, while gadrooning and engraving on silver were transcribed into decoration on porcelain from Meissen to Canton.

The impetus for such changes was often provided by individuals or small groups. Queen Mary II's collection of porcelain was arrayed on shelves and wall-brackets and about mirrors. Not only did Augustus the Strong find time to promote and encourage the production of true porcelain at Meissen and to collect a vast array of Japanese, Chinese and other porcelain at the newly-adapted 'Japanese Palace' at Dresden, but between 1721 and 1733 he also caused it to be meticulously inventoried.

Merchants at Lisbon, Amsterdam and London in particular, many of them related to the nobility, made fine collections of the porcelain in which they traded, and had their dinner-services decorated with coats of arms. Their wealthy daughters frequently married into more aristocratic families and thus the wealth of an East India Governor of Madras would come to the family of a powerful and noble politician, as was the case with Audrey Harrison whose father had been the Governor at Fort St George and whose husband was Lord Lynn, son of Charles, Viscount Townshend, the Tory minister.

In England, early armorial services were ordered from China by important London merchants and their influential political friends: by Mr Speaker Compton (c 1715); by Lord Chancellors, Somers (c 1714), Harcourt (c 1725) and Hardwicke (c 1728); by the Leader of the Opposition, Pulteney (c 1723); by the great financier, Gibbon (c 1727); by Lord Chief Justice Trevor (c 1722); by Lord Chief Baron of the Exchequer Wearg (the founder of the National Debt) (c 1720); by 'Princely Chandos' – the extravagant Duke of Chandos (c 1720); by the founder of the great family of Pitt, 'Diamond Pitt' (c 1705); by Talbot Bishop of Durham (c 1755) and by most of the directors of the ill-fated South Sea Company and the East India Company. A similar list for Spain and Portugal would show a greater proportion of governors and captains of their far-flung possessions overseas, while for Holland before 1730, the greater part of armorial porcelain was ordered for those connected with the Dutch East India Company, although, in line with earlier initiatives, there was a spirited attempt to stimulate sales with the production of four series (between 1700 and 1725) of armorial dishes with the arms of Dutch cities and provinces and those of neighbouring countries (no 95).

It would seem, in fact, that it was again the Dutch who first recognized the importance of stimulating the market with new and interesting products from China,

rather than merely supplying it. They had already been largely responsible for prompting the manufacture on a wide scale of objects for domestic use in *famille verte*, 'Chinese Imari' and blue-and-white porcelain for the markets of London, Amsterdam and the Hague. Although the Portuguese had ordered family armorial wares and other porcelain with personal devices in the seventeenth century it was the Dutch who had promoted the copying of delftware in the East, had used a medal, about 1692, as the original for a Chinese service (the 'Riots of Rotterdam'); offered 'souvenir' dishes with the arms of cities and provinces; and used porcelain decoration about 1720 to warn against the dangers of financial speculation at a time when Western Europe was in the grip of the greatest monetary upheavals before the present century.

It is arguable that after 1720, with the possible exception of religious scenes (which may also have owed as much to Dutch initiative as to any other) no other national company made a similar attempt to produce popular designs suitable for the European market until after the accession of the Emperor Ch'ien Lung in 1736. In 1728 the permission given in Holland for special currency for the Dutch East India Company ('Vereenigde Oost-Indische Compagnie') was celebrated by the production of tea-services and plates bearing the Dutch Company's monogram (VOC) and the date. Before this time the Company had employed artists to adapt the designs of Delft to Chinese porcelain and about 1730, too, it is clear that various pieces of Meissen porcelain were sent to China for copying.

But it was in August 1734 that the most important step by any European company was taken, to transform the hitherto haphazard and occasional use of European devices and subjects on porcelain still essentially Chinese in taste, into the systematic use of Chinese technical and productive skills to make porcelain for Europe – designed and specified in quality, quantity and subject. This was to have far-reaching consequences for the manufacture of Chinese export porcelain for a century.

The appointment of Cornelis Pronk in that year 'to make all designs and models . . . of all such porcelains as will be ordered from time to time in the Indies' was the logical step for the Dutch East India Company to take to popularize the already surprisingly large imports of Chinese porcelain, and increase the Dutch share of this growing market. (In the same year (1734) the two British East Indiamen *Grafton* and *Harrison* alone carried 240,000 pieces of porcelain, plus 240 chests containing special orders, such as armorial porcelain, usually included under 'private trade' and ordered by the captains or supercargoes for their acquaintances.) Cornelis Pronk had a contract with the Dutch Company for three years and it is reasonable to suppose that he only worked for this period, for there is no record of any renewal and the volume of his work does not apparently justify one. Nevertheless he almost certainly produced a greater number of designs than he has so far been credited with (see no 296). It is clear that he designed for dinner-, coffee- and tea-services and for decorative urns, jardinières and wall-sconces, drawing on his imagination and on his own concept of *chinoiserie*, which had become a leading decorative style in European silver in the late seventeenth century and figured also on Meissen porcelain from its beginning.

The creation of these new designs and their translation to Chinese porcelain almost certainly proved very expensive. The Chinese and Japanese painters attained a high degree of accuracy in copying, which promised much, but at a much greater cost than was expected and consequently the quantities ordered were disappointingly small. But a more serious factor soon emerged which was to destroy the viability of the whole project: the realization by the other East India companies of the need to

compete. One voyage by the Dutch Company may have sufficed to convince them that without some effort on their part, the Dutch would be able to supply an interesting, if expensive, range of special porcelains not available elsewhere, and their response was rapid and decisive. There already existed in Europe a highly-developed production of engravings for books and for sale as separate prints. It was to these that the companies now turned, selecting a range which was known to be popular, and having them copied on to porcelain within borders of standard, and frequently Chinese, design. Under this arrangement the Chinese could vary the borders and adapt the engravings to suit individual pieces or shapes. The design work had cost nothing, and more important, the popularity of each original could be gauged from its known sales in printed form, thus avoiding costly experiments which might prove less saleable.

Events moved rapidly. In no more than a decade, from 1735–45, some hundreds of scenes: historical, political and commercial, topographical and personal, mythological, religious, literary, picturesque and domestic had been translated on to porcelain in the form of dinner-, tea- and coffee-services, on commemorative punch-bowls, mugs, garnitures and vases. Such pictorial decoration had earlier been popularized on delftware and on glass, but the tradition lacked a suitable medium for it to appeal greatly to the more sophisticated owners of the European mansions which were now being built and furnished. Chinese porcelain was just such a medium, legendary in quality and highly esteemed, so that the latest vogue could be enjoyed with the greatest grandeur and least offence. There was porcelain which was more suitable for the display cabinet than for use, and into that category probably fell, for instance, plates decorated with the medal commemorating the treaty of Frederiksborg, though a similar medal marking the launch of a ship in 1739 in Copenhagen was used as the basis for decoration of an actual tea-service.

The Jacobite fervour of the 1740s in England produced a number of porcelains designed for use, but after 1746 it was probably only the punch bowls which witnessed any fervent toasts. There were other heroes and villains to be remembered, and the Duke of Marlborough and Lord Anson shared the porcelain stage with the gypsy procuress Mary Squires who was wrongly condemned for trying to sell a neer-do-well serving girl into prostitution. What seems to have been a more cautious approach on the part of the French company to trafficking in popular or partisan themes did not prevent more graceful subjects, many of them with erotic overtones, being sold on wider markets, notably those after such French and Flemish artists as Bloemart (1564–1651), David Teniers (1610–90), Picart (1673–1733), Watteau (1684–1721), Lancret (1690–1743), Boucher (1703–70), Thomassin, Larmessin, Nicholas Ponce, Du Clos, Dusart, Le Mesle and Moreau le Jeune. There are also two interesting and elaborate services not yet fully explained, but dating from about 1746, which bear devices possibly referring to Louis XV and Madame de Pompadour, familiarly called 'Poisson' (although certainly not with her consent).

The idea, once established, of producing a series of porcelain plates with related designs led to a number of such sets being made with religious and mythological subjects. Some employed borders already in use, others (usually tea-services where there was no space for this additional decoration) have plain black and gilt lines, and yet others have borders specially designed after purely European patterns. It is of interest that no exact original for any of these European borders has been found with the exception of those taken from gilt Meissen scroll-work. Many follow types of

decoration favoured on delftware, and a number appear to derive ultimately from designs of a kind used on Vienna porcelain of the du Paquier period. Le Corbeiller shows an example which illustrates the closeness of some of the new Chinese borders to European originals, but this does not explain how they came to be used in China with different variants – for the Chinese could not, themselves, have adapted them.

The answer must be that just as the Dutch had set in motion the idea of new decorative subjects for Chinese porcelain, so either they or other Companies must have sent drawings of a series of border designs to go with them. There is no evidence of such European borders being used before about 1738, but they were certainly in use by 1742 (witness an armorial plate with peacocks and scale border dated 1742 in the Rouse Collection). It is evidence of the lasting appeal of some of these borders that the same is used on an armorial service dated 1756 and again on a portrait tea-service made for Herrn. Geelvinck after a print of 1758. The date of 1738–40 coincides with the appearance on armorial services of rim cartouches after Meissen, and again all the evidence points to this innovation taking place after 1736 and the death of the Emperor Yung Chêng. But it would seem there was little connection between the more relaxed trading situation in the reign of Ch'ien Lung and these new scenes and borders, the use of which clearly stemmed from the original initiative of the Dutch in appointing Pronk in 1734. Some of the borders themselves may even derive from his interpretations, for he shows himself well able to devise trelliswork designs – indeed this was one of his 'hallmarks'.

The revolution in style of export porcelain which started with Pronk's designs carried on in more diverse and mixed forms until the end of the century. From time to time political or historical events were of enough importance, or at least sufficiently caught the imagination, to result in their being copied on porcelain. John Wilkes' two great 'crusades' – the issue of no 45 of the *North Briton*, and his election as Lord Mayor of London nearly a decade later, were both displayed. The scandalous or inept British governments of the 1780's were the subject of various lampoons including the most intricate example after an engraving by 'Hanibal Scratch', about 1785. Similar examples of controversial political import are not found on porcelain made for continental countries, but commemorative wares, with portraits of kings and queens (as for example those of King Frederick V of Denmark after Preisler's engraving) or with statues erected in Copenhagen and Lisbon were not uncommon. The Dutch marked their subjugation by the French in 1794 and the emigré French their loyalty to the Bourbon cause, while from the 1750's until well into the nineteenth century shipping scenes, including some of the more famous naval actions, were used in decorating punch-bowls, and occasionally dinner plates, for both the European and American markets.

Perfection in the use of opaque enamels of the *famille rose* palette after their discovery about 1720, and very skilful painting *en grisaille* from about 1728, provided the Chinese decorators with a full range of colours with which to satisfy the needs of their export trade. The armorial service made for Lord Torpichen about 1740 uses an almost complete palette of some ten colours, while the Okeover service (no 413) of the same period proves the Chinese decorator's thorough mastery of the 'foreign colours' (*yang ts'ai*). There seemed nothing then to prevent production over many years in which exquisite workmanship might be matched by the continuing interest of the subject matter. Alas, this ideal was not realized: a reflection perhaps on the extent to which the decorative arts are subject to hard considerations of commerce.

From before the turn of the seventeenth century there had always been a great preponderance of standard, everyday ware imported from China which was sold by china merchants in all countries – in London, Amsterdam, the Hague and Lisbon, and later in Paris, Copenhagen and Gothenburg. Such ware was at first predominantly blue-and-white in standard patterns with little European influence, and later, enamelled in *famille rose* style employing simple landscapes, birds and flowers. It was not however this bulk which represented the work of the designers but the much more valuable 'private' cargo which was carried as a concession by captains and supercargoes. This was usually financed by the companies, although the profit was however made by the company servants themselves. In England these concessions amounted to 4 per cent of the cargo's value for the captain early in the century and about 1 per cent by the close (with lesser percentages for other officers). As porcelain was only a small percentage of all the trade with the East but a large percentage of the 'private' trade, the share taken by this finer porcelain may have been between 10 and 20 per cent of the whole, although possibly not as great as the 25 per cent suggested by the sources quoted by Le Corbeiller. The only distinction made between Company and private trade by Morse in his *The Chronicles of the East India Company trading to China* is that the Company trade is expressed in 'pieces' while the private trade is expressed in 'cases', and there is no record of the contents of these, although other evidence suggests that private trade porcelain was often ten times – and in the case of the Okeover service, perhaps a hundred times – as expensive as the Company's.

With the immediate success of the European decorative designs the Companies were not long in pressing the Chinese to copy the shapes of European porcelain originals as well as those of silver, and this coincided with the wider use of Meissen porcelain in Europe. They were to draw increasingly on the success of new factories at Vienna and Sèvres, and in Scandinavia, Germany and England, as well as on those still making faience. In addition to table-services there was a growing demand for purely decorative pieces such as animals and birds.

Because of the complex cross-currents in ceramic design at this period it is not always easy to trace the origins of the Western shapes in Chinese porcelain. In this collection, in one instance a French silver tureen will have been copied in Rouen faience which then served as the source; while in another, a tureen has its origin in Josiah Wedgwood's adaptation of a Sèvres model. The Chinese pistol-handled urn, so popular at the end of the century, has a history which stretches back to a sixteenth-century design by Stefano della Bella, published in England in the seventeenth century, and used by Wedgwood in the eighteenth. A Chinese albarello of *c* 1735 derives from Spanish or Italian faience, but a hot water jug of *c* 1800 directly copies an English silver original. One looks in vain for the exact original of the graceful chestnut basket and the not-so-graceful loving cup. Both pottery and porcelain from many of the major European factories provided models: German stoneware of the seventeenth century and porcelain from Meissen, Höchst and other German factories; Sèvres porcelain and Rouen faience in France; delftware and Tournai porcelain in the Lowlands; faience from Marieberg in Sweden and also from Spain; in England, porcelain from Chelsea, Bow, Lunds Bristol, Worcester and Derby, as well as Wedgwood and other Staffordshire pottery: the list could be greatly extended.

Among the more illuminating and entertaining items made to gratify Western tastes is a sizeable output of figure models. Until the eighteenth century the market for these in China itself had remained limited: figures were made for religious

purposes to furnish temples and domestic altars, and various symbolically auspicious animals, often in the form of usable vessels such as ewers or water-droppers for the writing-table are found, but beyond this there seems to have been little call for such 'novelties' except perhaps as toys for children. In the West however there existed a demand for 'curios' amounting in some quarters to a passion, and it was surely for this reason that from the beginning of the eighteenth century output multiplied so greatly. Before this, East India Company records show that the Japanese had frequently been pressed by the Dutch to provide 'specialities' and production received an early impetus from this source. The varied output of *blanc-de-Chine* figures in the late seventeenth and early eighteenth centuries well illustrates the influences of Chinese piety on the one hand and European sentiment on the other which played their part in the phenomenon.

The figures of *c* 1700–15 in *famille verte* style representing members of the French Court seem to have been created from two-dimensional prints, and are a particularly interesting departure in the extension of modelling skills to the service of the foreigner. They were later followed by some others of quite ambitious size and richer colouring (no 647), in which Western dress and other features were again reproduced as faithfully as knowledge and expertise permitted. In due course however a new and more reliable means of transmitting orders was found when actual models in European porcelain were sent for copying, and this trend continued occasionally even in the nineteenth century.

Chinese figures of domestic as well as fabulous animals and birds in the *famille verte* style were already numerous in the collection at Dresden. For the period *c* 1730–50 however there is an increasingly competent and adventurous range of models, sometimes quite plain in colouring, but often making use of the full spectrum of the *famille rose* palette, strikingly typified by the magnificent models of pheasants and other birds (no 613). It is possible to distinguish those specially commissioned which adopt a highly naturalistic style of enamelling, and were largely inspired by examples from the Meissen factory. Models of dogs such as spaniels and pugs (nos 622, 623) seem particularly indebted to this source, although the immediate originals of some have to be sought elsewhere, perhaps in the English factories. Some of the animal models of the third quarter of the century take the form of tureens for the dinner-table: a fancy that was encouraged especially by the faience factories of Strasbourg and Höchst; and of these the large specimens in the form of geese and ox-heads (no 622) are particularly striking. If domestic animals provide most of the models there are also wilder creatures: boars, monkeys, elephants and birds of prey. Both the human and animal figures added greatly to the interest and gaiety of the export range, but it seems probable that the greater part of the orders came from the Continent rather than from England.

It is clear from the very high percentage of captains and super-cargoes who ordered armorial services for themselves or their families – over 50 per cent of all British captains sailing to Canton in the period 1709–1802 did so – that the attraction of porcelain was very great for those engaged in the trade. This was reflected too from 1730 onwards and increasingly after 1740 in the ordering of bowls with shipping scenes, or services showing the ports of call, such as Madras for the British and Batavia for the Dutch – and (nos 198, 203), scenes of Whampoa and life at Canton. The Pearl or Tiger River which stretched some sixty miles up to the city of Canton was a legend for those sailors who had not been there and a place of enforced idleness for those that

had. The 'Bogue' (a corruption of Bocca Tigris) and the anchorage at Whampoa were well known from Chinese paintings and porcelain. The final journey to Canton in small boats and the view from the River of the thirteen factories are frequently seen particularly on the punch-bowls of the later eighteenth century. The near loss of the *Haslingfield* in 1743 and the foundering of the *Grafton* in 1751 are both recorded. Naval actions were depicted, ranging from Captain Gardner's capture of the *Foudroyant* in 1759 to the duel between the *Macedonian* and the *United States* in 1812, and were usually of very high quality. But greater still was the quantity of souvenir ware of a more personal character ordered from the china shops in Canton, ranging from bowls such as that with a Captain's name and ship – 'James Ferrier in *Kintrocket*' – to entire tea-services with ship designs, which were sometimes copied from the manifest documents, and bear little resemblance to the vessel actually anchored in the Pearl River.

While the volume of the porcelain trade with Europe grew rapidly during the second half of the eighteenth century to reach a peak about 1790, its quality fell as the size of bulk orders and protective duties in Europe rose. The carefully-designed European-style borders of the 1740s and 1750s had become the more mechanical festoons of the 1760s and the thin lines of leaves and husk chains of the 1780s. The time spent in enamelling these at Canton was reduced to a small fraction of that required earlier to decorate and elaborate ware of the Yung Chêng period. The central designs suffered too, and the small and sparsely-spread flowers of the third quarter of the century are a sad imitation of their originals at Meissen and Sèvres.

Perhaps as a reaction against falling standards, from the 1760s onwards a growing volume of porcelain was decorated at Ching-tê-chên with elaborate underglaze blue borders, landscapes and riverscapes. This development coincided with shipment of the porcelain by way of the rivers to Nanking, and thence by sea to Canton where the enamelling of armorials or pictorial designs was carried out. Such blue-and-white porcelain was soon known as 'Nankin porcelain' (because it appeared in Canton to come from there), and is so referred to in an article in the *Gentleman's Magazine* of 1776.

Underglaze blue designs were evidently popular among East India Company servants in India and many of the armorial services with such decoration were made for these families. But it was not only the growing number of British in India who used personal Chinese porcelain, for many native Indian rulers did so as well. Surajah Dowlah, who was defeated at Plassey, had his Chinese service with the modest legend 'The Emir of India, the mightiest citizen, Surajah Dowlah, the Light of Religion, the Khan, Bahadur, Ready in War, 1184AH' (equivalent to 1770 AD). Grand viziers and successful Parsee merchants could boast such porcelain and in the second quarter of the nineteenth century a rich service of the period has on every piece 'Cowasjee Family' (an Indian family which controlled the principal shipping company in Bombay, and was among the earliest to be honoured by the conferment of an English baronetcy).

It was no novelty for fine porcelain of special design to be delivered to Persia and the Near East. Wares with geometric patterns of flowers and other adaptations of the Persian tin-glazed wares, also porcelain inscribed with Arabic phrases were made in the eighteenth century. In the nineteenth century, as the ceramic industries of the West flourished, so the Near Eastern market increased in importance for the Chinese. A new but short-lived peak of quality was reached by 1850 as witnessed by the

services for the Nasir'ud Din Shah (as no 496). Standards received a severe setback when the kilns at Ching-tê-chên were destroyed in the Tai Ping Rebellion of 1854, and full production was not restored until 1863.

It had been the entry of American ships and traders into the Chinese market in 1784 that had revitalized the porcelain industry for the succeeding half century. The Americans did not trade as a national company like those from Europe but in the early days each ship drove the best bargain it could, and later, companies from several of the maritime provinces of the Eastern seaboard had offices in Canton. The Americans found willing co-operation from Chinese merchants who must have regretted their declining trade and the fall in standards. Britain, as the only major European power at Canton after 1790, raised her duties so that they reached 150 per cent in 1800. The simplest form of plain enamel band at the rim was all that the Chinese could economically supply in answer to the rising quality and new designs of Worcester, Derby and Spode. The repetitive slits on the pierced borders from Canton were no match for the creamware creations of Leeds and Liverpool. At last the mechanization of decorative printed patterns in Staffordshire proved a formidable competitor for even the nimble fingers of the Chinese painters and they turned readily to supply the new American trade, where they could meet the competition on equal terms.

The Americans preferred the more elaborate and decorative bands of enamel which were often overlaid with patterns of gold, tassels and stars. They favoured oval vignettes with views such as those of the Delaware River and Mount Vernon, and two of the finest bowls of this period are those decorated with scenes of New York harbour and the Pennsylvania Hospital. Such scenes were exactly contemporary with others of Versailles, and of the Mansion House in London. But it was the opportunity to show an awakened patriotic fervour by displaying a great variety of American eagles, the arms of New York, or the badge of the Society of Cincinnati which became the hallmark of the first two decades of the American trade. No fewer than twenty different eagle designs appeared on porcelain, copied at first from the Great Seal of the United States, and later from coins and from shipping and insurance documents (no 510). The eagles and arms of New York were supplemented by initials and sprays of flowers. By 1810 it can no longer have been either fashionable or novel to eat and drink from such porcelain; and after a brief period when a number of tea-services were specially commissioned with scenes after print sources *en grisaille* and in sepia, taste reverted to 'oriental' subjects (possibly also on account of the extra cost involved in special designs). These often incorporated figures and were executed in the 'mandarin' palette – a bright blend of rose-pink, blue, orange-red, purple and green enamels. By 1820 yet another style of decoration had appeared, consisting of shaped panels with rose-pink flowers and birds set in an elaborate ground of green and gold scroll-work and punctuated by occasional birds and butterflies, surrounding a central medallion. Popularly known as 'rose medallion' ware, this must surely have owed as much to the growing importance of trade with the Near East as to any direct stimulus from American traders. 'Rose medallion' was to retain its popularity for over a century and, at its best from the 1820s until after 1860, sometimes incorporated armorials.

But profusion of design is no substitute for quality, and with few exceptions (no 496) this porcelain cannot be said to rival the production of a century earlier. The competent underglaze blue designs of the third quarter of the eighteenth century had meanwhile slowly stiffened and, with the notable exception of the pattern later called Fitzhugh, had been overtaken by a simpler and more sketchy style of pictorial drawing

and wash with simple trellis borders which was known from the 1820s as 'Canton ware', a term which denoted the port of export rather than the place of its painting.

So popular was the underglaze blue pattern first made specially about 1780 for Thomas FitzHugh, later a director of the Hon East India Company, and adapted to both armorial and non-armorial services about 1800, that the style was imitated in several colours of enamel. There are armorial services in sepia, all of which seem to have been made for the American market, in green and orange (also with armorials including eagles and in purple, grey, yellow and black – made probably in the main for Portuguese customers, for there are examples with the arms of local families in the Museum at Macao.

From the 1830s onwards there was little remaining originality of design, and with the unsettled political conditions which lead to the Opium War of 1840 and the subsequent opening of other Chinese ports to trade, the destruction of the kilns at Ching-tê-chên in 1854, and the fire which destroyed the renowned foreign 'factories' at Canton in 1856, there was no settled period of trading to encourage any fresh blossoming of style. Occasionally, opportunities were seized to revive interest in European markets – as with a vase to celebrate the accession of Queen Victoria, or some cups and saucers copying the 'Meissen revival' wares of the later nineteenth-century Dresden decorators (no 539); while for the American market there was a new generation of eagle displayed on a jug after a Victorian Ironstone original, and even services decorated in honour of the centenary of the signing of the Declaration of Independence. But this did not amount to a co-ordinated attempt to rebuild a trade in porcelain which a hundred years earlier had dominated the markets of Europe.

Today a century has passed since the last European or American designs were sent to China, and in that time much of the knowledge of this ancient trade has been lost. It is only in recent years that serious efforts have been made to rediscover (even to reproduce) these strangely hybrid porcelain wares which so seduced Europe in the eighteenth century and America for half a century thereafter. But the many conditions which created the era of china for the West no longer exist: such porcelain will not be made again.

BLUE-AND-WHITE PORCELAIN

2
Ewer with Persian inscription
Mark and period of Chêng Tê (1506 – 21), height 10¼ in
(31.8 cm)

Square in shape and massively potted, with a tubular neck. Late
Near Eastern additions, possibly Turkish, are the angular
replacement handle and curving spout of gilt copper with chased
scrolling ornament, also the inverted cup of 18th-century
porcelain having a hinged gilt-metal mounting and finial which
serves as a lid.

Phrases in Persian are painted in two medallions on the neck
and in two cartouches on the body which alternate with others
containing floral designs, each panel being framed by four flower
sprays. The inscription may be translated: 'O ye caller to prayer in
the House of Religion / Come to perform the ablution and
prepare yourself for prayer.'

The reign-mark appears on the base in the customary form,
comprising six characters written in two columns read downwards:
Ta Ming Chêng Tê nien chih (Great Ming (dynasty) Chêng Tê
period made).

Porcelains of this quality and type bearing Mohammedan
inscriptions are among the best products of the Chêng Tê reign,
one during which Muslims enjoyed unusual favour at the Chinese
Court. Many of them are writing-table accessories (boxes,
brush-rests etc) which were perhaps made specially for the use of
these Court officials. This ewer is exceptional in having been
exported. The form, which is rare if not unique in Chinese
porcelain, was in all probability derived from Iranian metalwork.

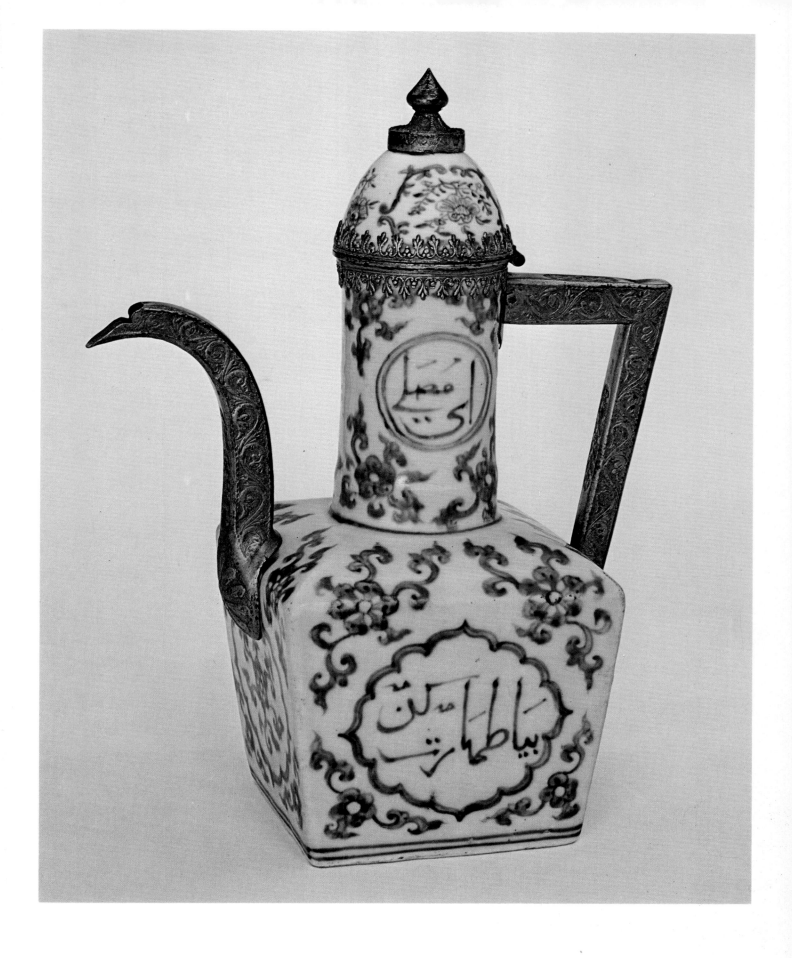

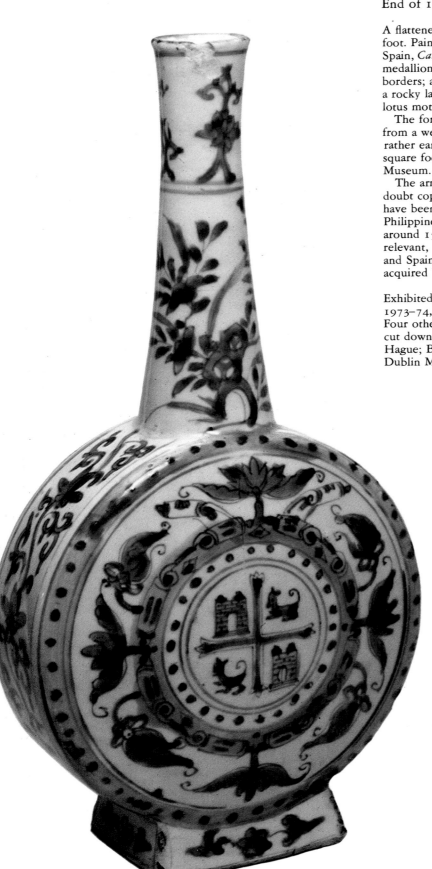

Flask with the Spanish royal arms
End of 16th century, height 12 in (30.5 cm)

A flattened 'pilgrim flask' with tall, tapering neck and spreading foot. Painted in 'outline and wash' with on one side the arms of Spain, *Castile and Leon quarterly*, with scrolling frame in a medallion with a surrounding band of plant sprays, within dotted borders; and on the other with a seated scholar and servant-boy in a rocky landscape; with plants, rocks and insects on the neck, and lotus motives round the sides.

The form, an unfamiliar one in China was probably borrowed from a western Asiatic prototype in metal: see for instance a rather earlier Persian bronze pilgrim flask with tall neck and a square foot ascribed to the thirteenth century in the British Museum.

The arms, which are those of Philip II (1556–98) were no doubt copied from a coin. It is not clear how the piece would have been ordered: Spain had limited access to China via the Philippines from the 1570s and later from Formosa, and for a year around 1580 enjoyed a concession at Pinal near Macao. More relevant, however, may be the union of the crowns of Portugal and Spain which took place in 1580. The collection of porcelain acquired by Philip is said to have been very extensive.

Exhibited: New York, China Institute (*China Trade Porcelain*, 1973–74, Cat 2, illustrated).
Four other examples are known: G. Duff Collection, Lisbon (with cut down neck and later silver mount); Gemeentemuseum, The Hague; British Museum; and a private collection in Ireland, Dublin Municipal Gallery of Modern Art.

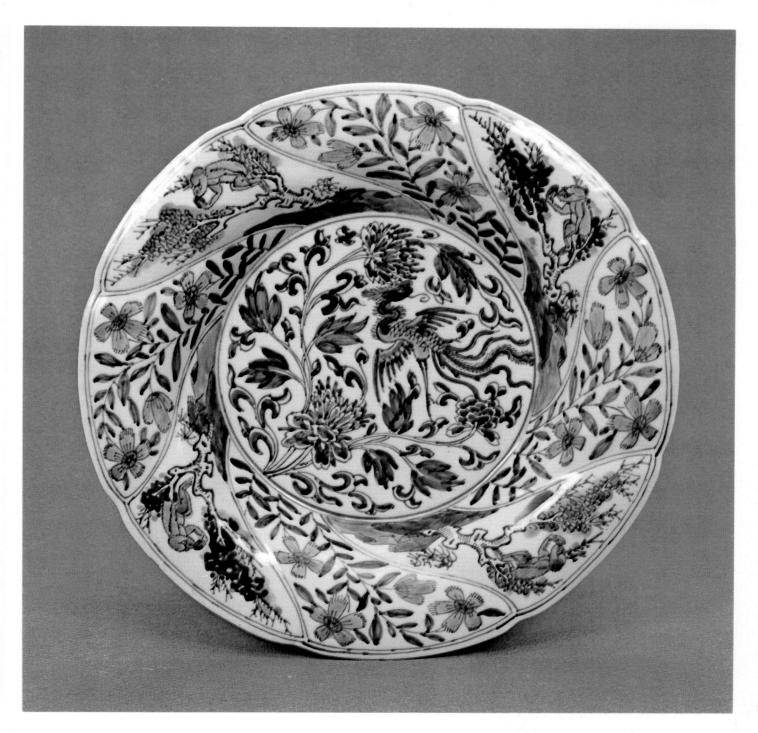

18
Plate
c 1700–1720, diameter 8½ in (21.6 cm)

Plate with a broad, curving rim spirally fluted in eight lobes.
Finely painted in rich blue with a phoenix and a peony spray in
the centre, and in the radiating panels with a monkey in a peach
tree alternating with a spray of carnation; on the reverse are eight
flower sprays.

A fine and characteristic example of the K'ang Hsi cobalt-blue
and style of painting. The plate imitates a common European
silver form, which may however have been transmitted by way of
an intermediary in delftware.

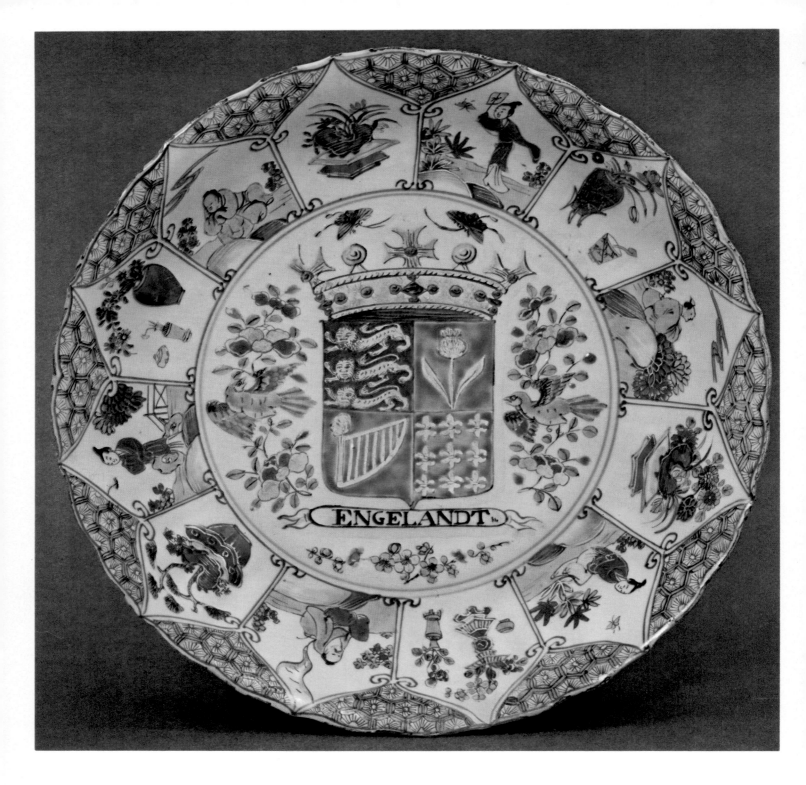

FAMILLE VERTE WARES

95
Armorial dish
K'ang Hsi period, *c* 1710–1720, diameter 12½ in
(31.7 cm)

A famille verte dish bearing the arms of England (*ENGELANDT*),
which are presented in a pictorial form: 1st quarter: the three

lions of England. 2nd quarter: on an azure field, what is probably
the thistle of Scotland. 3rd quarter: on an azure field a golden
harp (for Ireland), 4th quarter: on an azure field *France ancient*
(powdered with fleur-de-lys).

The form of the arms reinforces the view that these dishes were
for decorative display rather than for personal or official use.

A copy in polychrome Dutch delftware is in the Rijksmuseum,
Amsterdam. The 'Engelandt' dish exists also in another series
painted in underglaze blue and *famille verte* enamels.

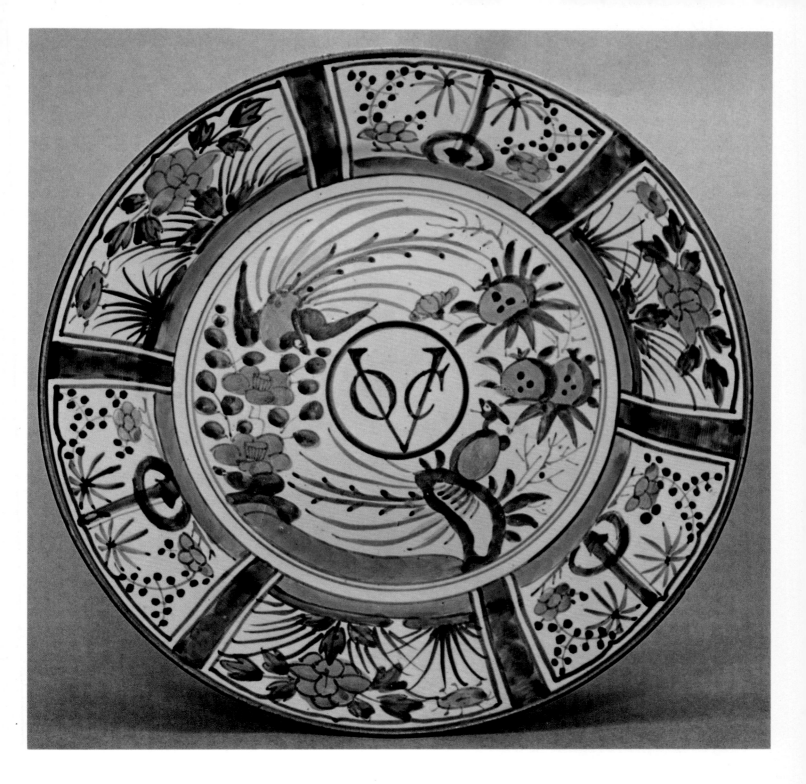

JAPANESE PORCELAIN

100
Plate
Third quarter of 17th century, diameter 14⅜ in (36.6 cm)

Shallow plate with spreading rim. Painted in somewhat purplish
grey-blue is the monogram *VOC* of the Dutch East India
Company surrounded by a pair of long-tailed birds with
pomegranate, camellia and rocks, and alternating plant motives in
six panels round the rim. Plain back.

The purplish-blue and rather sketchy, simplified style are
characteristic of much of this Japanese export ware. The design is
roughly adapted from Chinese blue-and-white dishes of the earlier
part of the century which were no doubt supplied by the Dutch to
the factories as models for their requirements. The monogram
'VOC' stands for 'Vereenigde Oostindische Compagnie', and many
such pieces, mainly dishes and plates with designs related to this,
were produced during the period *c* 1658–83, probably for use in
the Company's various overseas offices; very similar wares are also
found lacking the monogram.

It is of interest that fragments of rather similar blue-and-white
dishes have been discovered at the Sarugawa kiln-site at Arita.

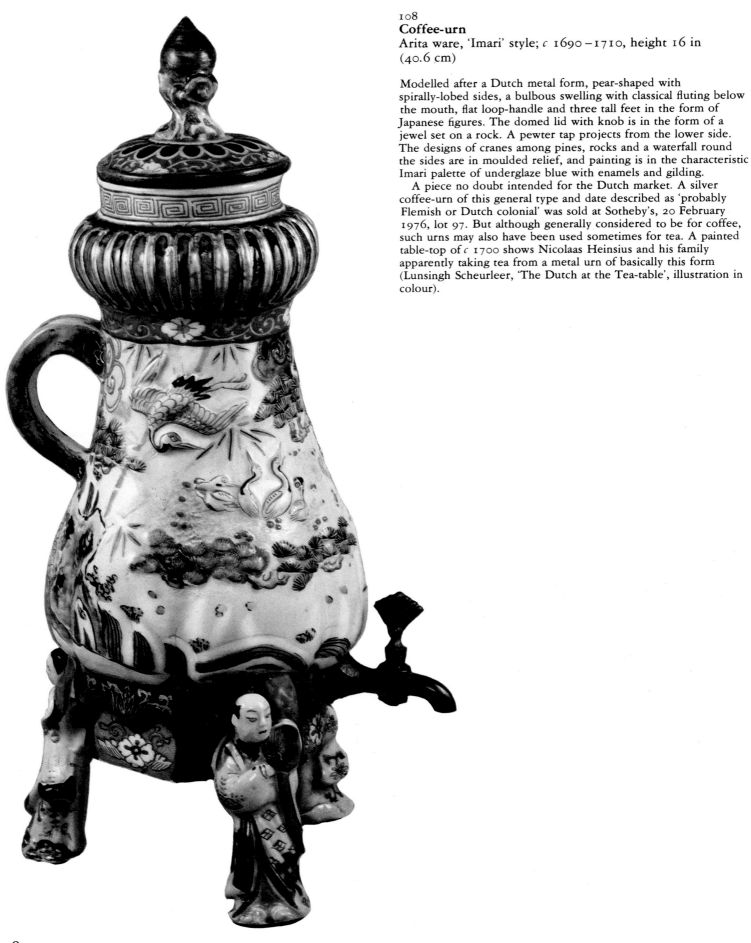

108
Coffee-urn
Arita ware, 'Imari' style; *c* 1690–1710, height 16 in
(40.6 cm)

Modelled after a Dutch metal form, pear-shaped with
spirally-lobed sides, a bulbous swelling with classical fluting below
the mouth, flat loop-handle and three tall feet in the form of
Japanese figures. The domed lid with knob is in the form of a
jewel set on a rock. A pewter tap projects from the lower side.
The designs of cranes among pines, rocks and a waterfall round
the sides are in moulded relief, and painting is in the characteristic
Imari palette of underglaze blue with enamels and gilding.

A piece no doubt intended for the Dutch market. A silver
coffee-urn of this general type and date described as 'probably
Flemish or Dutch colonial' was sold at Sotheby's, 20 February
1976, lot 97. But although generally considered to be for coffee,
such urns may also have been used sometimes for tea. A painted
table-top of *c* 1700 shows Nicolaas Heinsius and his family
apparently taking tea from a metal urn of basically this form
(Lunsingh Scheurleer, 'The Dutch at the Tea-table', illustration in
colour).

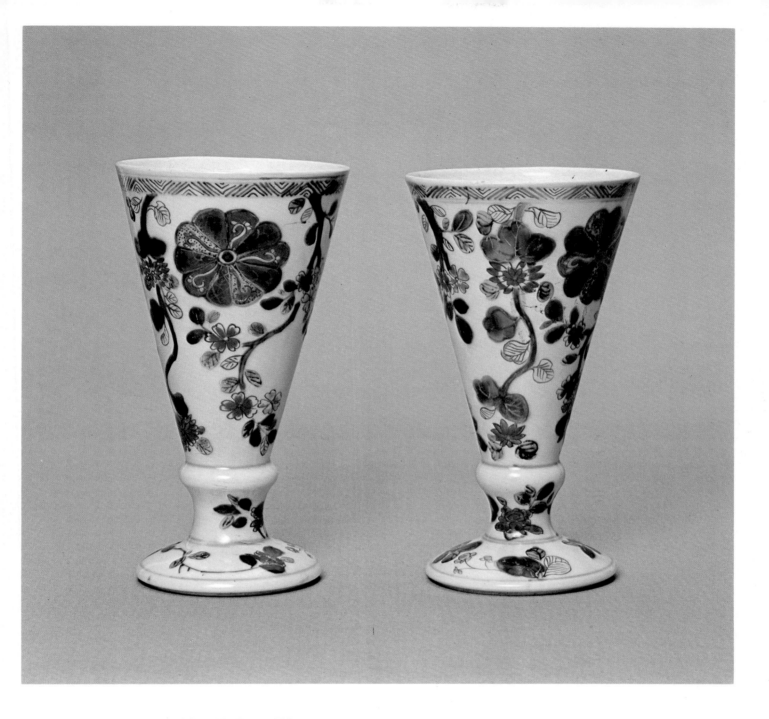

'CHINESE IMARI' STYLE WARES

119
Pair of goblets
c 1705–1720, heights 5 in, 5⅛ in (12.7 cm, 13 cm)

Copying European glass goblets or flutes, of tall conical form with
a knop above the foot; convex base.

Painted in underglaze blue, *famille verte* enamels and gilt after
the 'Imari' style with chrysanthemum roundels and flowering
branches; chevron border.

This is a typical European, and possibly English goblet shape
from about the last decade of the seventeenth century. A rich
source of design in such glasses is the series of designs produced
by Messrs Measey and Greene, London Glass Sellers, during the
latter part of the century for glasses to be made in Venice and in
London (*Sloane Mss*, British Museum).

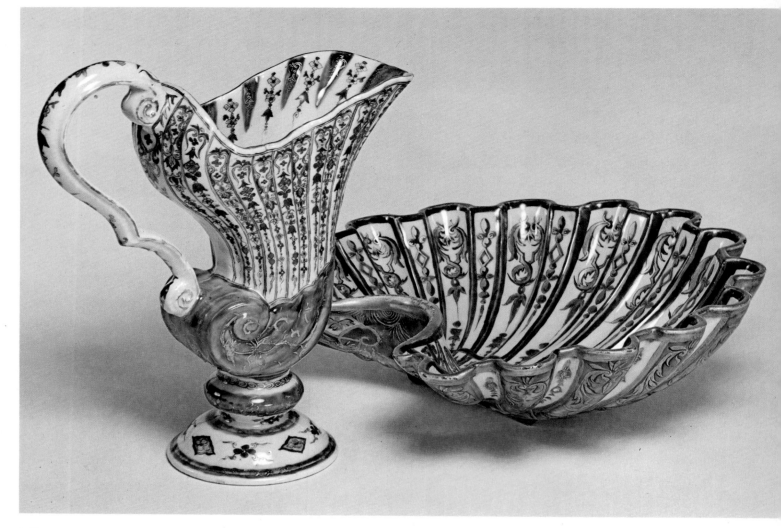

125
Ewer and basin
c 1720–1725, height of ewer 11¼ in (28.6 cm); height of basin 14⅝ in (37.2 cm)

The ewer is shaped like a nautilus shell, its voluted base upright on a knopped stem and domed foot, the double-curved baroque handle terminating above and below in scrolls. The basin resembles a large, deeply-fluted scallop shell.

The fluted panels of both pieces are heavily outlined and ornamented in blue, red and gold with pendant motives composed of simple jewel, floral and strapwork elements, while panels on the underside of the basin and also the heads of both shells display gilt scrollwork on a blue ground.

They copy European models probably of silver or pewter, the scallop shell in particular being common from the seventeenth century, although a ewer of this form has not yet been traced.

Some uncertainties about the date can at least be narrowed down. Pieces of essentially the same form are also found with decoration in early _famille rose_ style that cannot be much after 1730: for example, a ewer and a basin in the Victoria & Albert Museum. At the same time strapwork designs of the type seen here are anticipated by those found on an armorial service made for Sir John Fellowes that can be positively dated to the years 1720–21.

The same basic ewer and basin forms occur also in 'Canton' painted enamels: compare the set exhibited in New York, China Institute, _Chinese Painted Enamels_, Cat 8 from Lloyd Hyde's own collection and dated to the Yung Chêng reign (1723–35), which are described as copied from seventeenth century Portuguese silver.

Other example: Düsseldorf Museum.

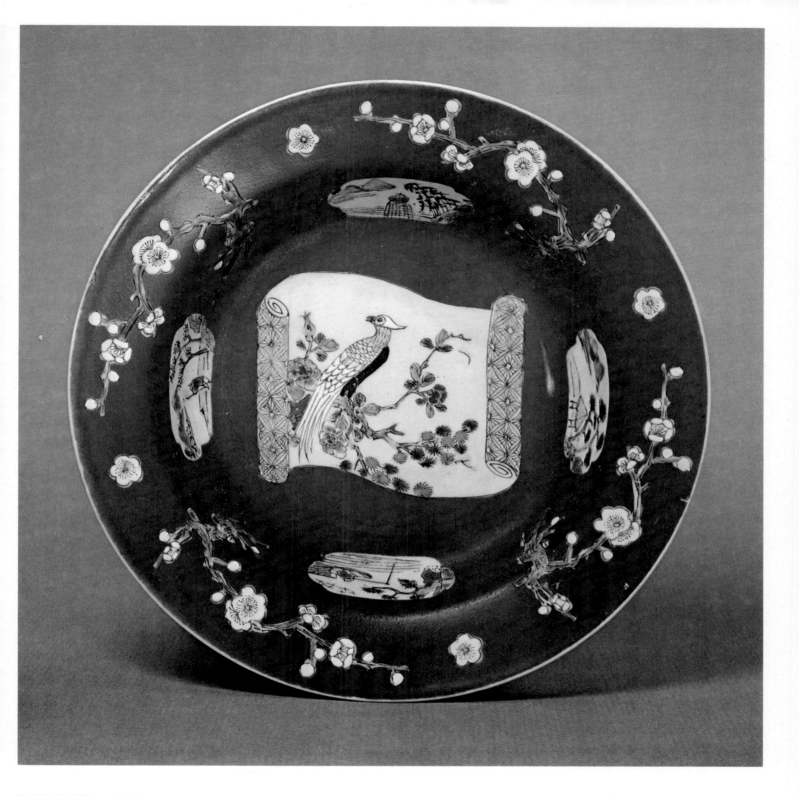

FAMILLE ROSE WARES

130
Plate

c 1730–1740, diameter 9 in (22.9 cm)

Painted with motives reserved on a ruby-pink ground. In the centre is an open scroll depicting a pheasant perched on a branch of pine with a peony spray alongside, surrounded by four tiny landscape cartouches and by scattered branches and blossoms of prunus.

On this plate the rich crimson-pink enamel from which the *famille rose* derives its name is used as a dominating ground colour. It is the same as that found on the underside of the so-called 'ruby-back' plates. In the Chinese symbolic view of things, the painted scroll carries in its designs connotations of matrimonial affection, riches, honour and long life, while the prunus sprays are emblems of spring. In point of fact, however, wares of this sort were made for Western rather than home consumption.

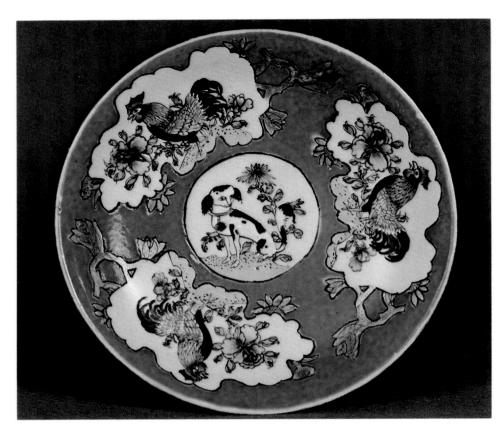

144
Saucer

c 1730–1740, diameter 4⅜ in (11.1 cm)

Saucer depicting a black-and-white dog sitting by a chrysanthemum, and leaf-shaped panels with gilt stems showing cocks and peonies reserved on the sky-blue enamel surround.

Part of a tea-service from which a cup and saucer, cream-jug and tea-caddy are reproduced by Williamson, pl VI in colour (from the Martin Hurst Collection). Many of such tea wares are of exceptional quality and their condition shows they were hardly, if ever, used by their European owners.

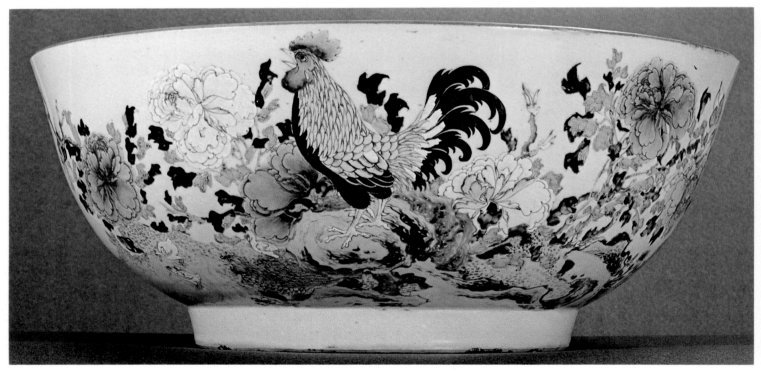

137
Punch-bowl

c 1735–1745, diameter 15½ in (39.4 cm)

Finely-painted punch-bowl with on one side a large golden cockerel crowing on a rockery among pink, white and yellow peonies, a hen below with several chicks, and on the reverse another golden cockerel and a white one. Inside on the bottom a chrysanthemum spray, and gilt floral border below the rim enclosing cartouches with lily and peony alternately.

The subject-matter here reflects Chinese symbolism according to which the cock is an emblem of literary success and the peony represents wealth and nobility. Despite the quality of its painting however this bowl was undoubtedly made with the Western market in mind, and from this time onwards many such punch-bowls were made decorated to order with subjects supplied by the purchaser.

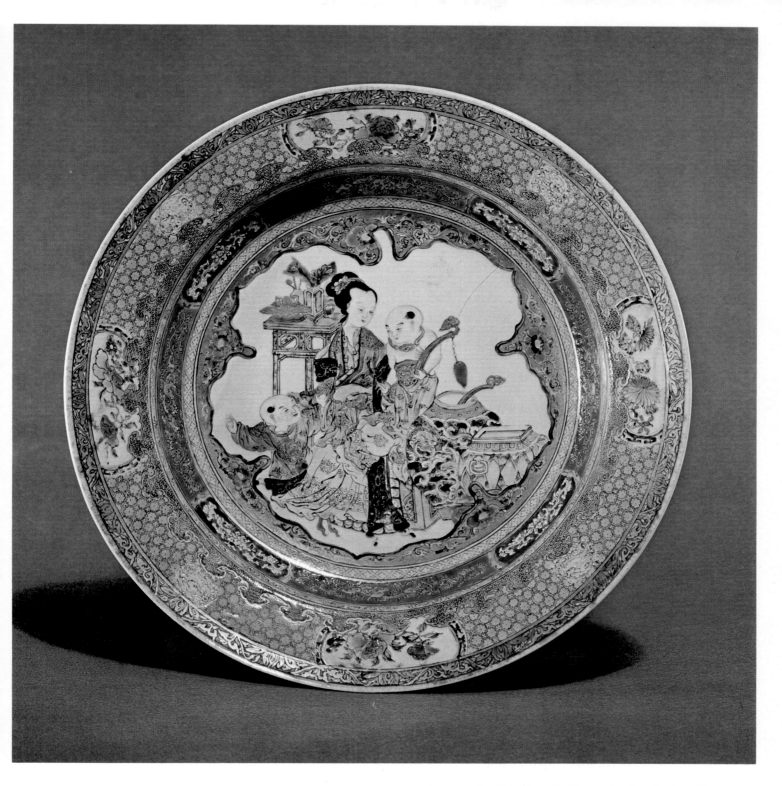

149
Plate

c 1730–1735, diameter 8⅜ in (21.3 cm)

A thinly-made, deep-rimmed plate with many-bordered decoration in *famille rose* enamels and gilt. Painted within a leaf-shaped panel is a scene of a finely-dressed lady with two children, one holding a *ju-i* sceptre, a table bearing various vessels, and two large jars. Round the rim are peony, camellia and chrysanthemum plants in four panels on a cell-diapered ground, with gilt tendril-scroll border at the rim. Other scrolling and diapered borders fill the well.

An example of the so-called 'seven-bordered' plate. The complex decorative scheme is handled with remarkable skill and employs the full range of the *famille rose* palette, with a variety of shaded colours and gilding. The name 'eggshell ware' is often given to this type of translucent thin porcelain. That such wares formed part of the export trade is indicated by the description of numerous lots in the sale of William Beckford's Collection at Fonthill Abbey in September-October 1823.

Some plates with the same subject bear the Yung Chêng reign-mark. Honey. *The Ceramic Art of China*, pl 88, illustrates a very similar plate with crimson 'ruby-back' in the Victoria & Albert Museum.

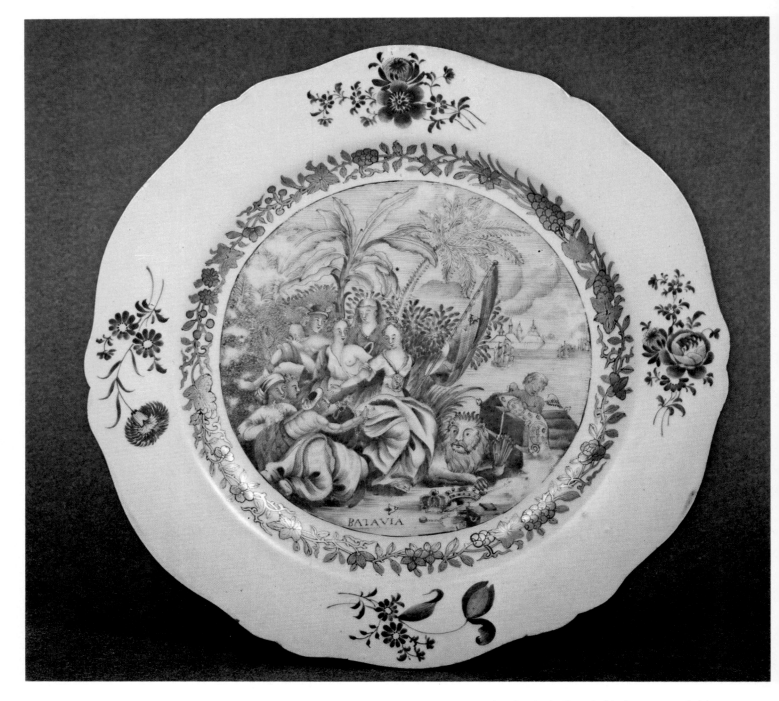

THE DUTCH EAST INDIA COMPANY

198
Plate
c 1755, diameter 9⅛ in (23 cm)

Decorated in puce enamel *en camaieu*, and with shaped (cut not moulded) rim, the well with gilt floral scrollwork. The centre depicts 'Homage to the City of Batavia', with the word *BATAVIA* at the foot.

The scene is after one of a number of prints showing the cities of Holland and her Empire receiving tribute, of which perhaps the best known is 'Amsterdam receiving the tribute of the four Continents' (by Jacob van Meurs, originally published in 1663).

Here natives bow and proffer gifts, and a wary lion rests his paw beside crown and sceptre; the flag bears the monogram of *VOC* (for the Dutch East India Company), while a cherub pours riches from a cornucopia and Mercury (also the God of

Commerce) watches benignly from behind, accompanied by goddesses. Ships sail towards the city in the distance.

The pride of the Dutch in their colonial possessions was more evident than that of the British and French in theirs at this date. Another example: plate, Nijstad Collection, the Hague.

THE BRITISH TRADING TO CHINA

203
Plate
c 1733, diameter 10 in (25.2 cm)

Decorated on the rim with four very fine river scenes *en grisaille* punctuated by two reserves in *rouge-de-fer* and gold. The river scenes are alternately of London (view from Southwark with London Bridge in the foreground and the City on the far side of the river), and of the Pearl River just below Canton (with a fort in

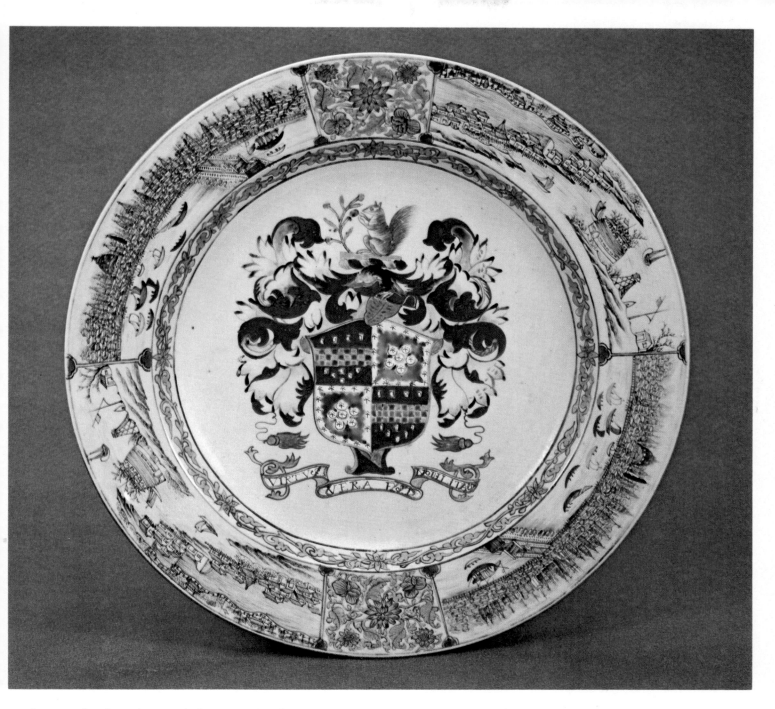

the foreground and wooden huts before the walls of the city on the further bank). In the centre are the arms of Lee of Coton *Gules a fess chequy or and azure between ten billets argent*, quartering Astley of Staffordshire.

This Lee service is, perhaps, the most interesting of all those four thousand armorial services made for the British market during the eighteenth and early nineteenth centuries. It combines Chinese and English topography, *en grisaille* and *famille rose* decoration, arms of excellent proportions and historical connections in both Britain and America. The view of London is after one of a number of late seventeenth- and early eighteenth-century engravings of London from across the river. These often had a reference over every spire and tower and a key below, for Wren's rebuilding of the City was one of the wonders of Europe at this time. The Chinese fort in the Pearl River was one of a number, several of which are well illustrated on a porcelain service of about 1745 illustrated by Le Corbeiller (no 39). They were known as 'Folly forts' but in the eighteenth

century no longer had a military purpose, and were in various states of disrepair. Undoubtedly some were used as warehouses and a more faithful demonstration of this appears on a late underglaze-blue service.

This service was almost certainly one of three made for Eldred Lancelot Lee of Coton who died in 1734 (though armorially there is no reason why it could not have been for his son Lancelot). Eldred Lee was born in 1650 and married Isabella Gough in 1713. He was the great-great-grandson of John Lee of King's Nardly, from whom were descended the Lees of Virginia. It is fitting that part of the service is now displayed at Washington & Lee University in Virginia close to the great recumbent statue of General Robert E. Lee.

Other examples: Metropolitan Museum of Art (gift of Mrs Joseph V. McMullan), Helena Woolworth McCann Collection, Beurdeley; Victoria & Albert Museum; pair dishes, four plates, Washington & Lee University, Virginia; plate of similar service and tea-cup without scenes, Reeves Collection.

CANTON

209
Plate
c 1745, diameter 9 in (23 cm)

Plate painted at Canton, with borders in blue enamels, the centre in *famille rose* depicting the implements of the shroff, or Chinese money-changer. The style of decoration is possibly for the Danish market, where blue enamel was particularly popular.

William Hunter in his book *The Fan Kwae in Canton before the Treaty Days*, published in 1882, recalls the great importance of the shroff in trading at that time when all coin was by weight and stamped by the money-lender with his mark as proof of value: 'Pieces of silver as well as dollars were shroffed and weighed before being deposited in the treasury. When that was done dollars no longer had a distinct existence . . . the guarantee of their purity and value is simply the stamp of the shroff or money house by which they are issued . . . imported dollars, from being continually weighed and stamped when passing from hand to hand became 'chopped dollars' or 'cut money' in Canton phraseology.'

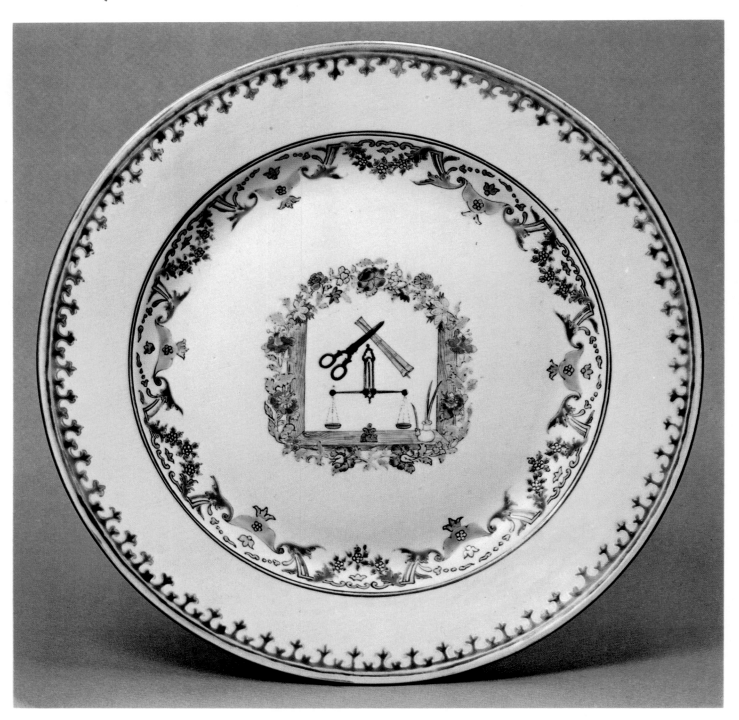

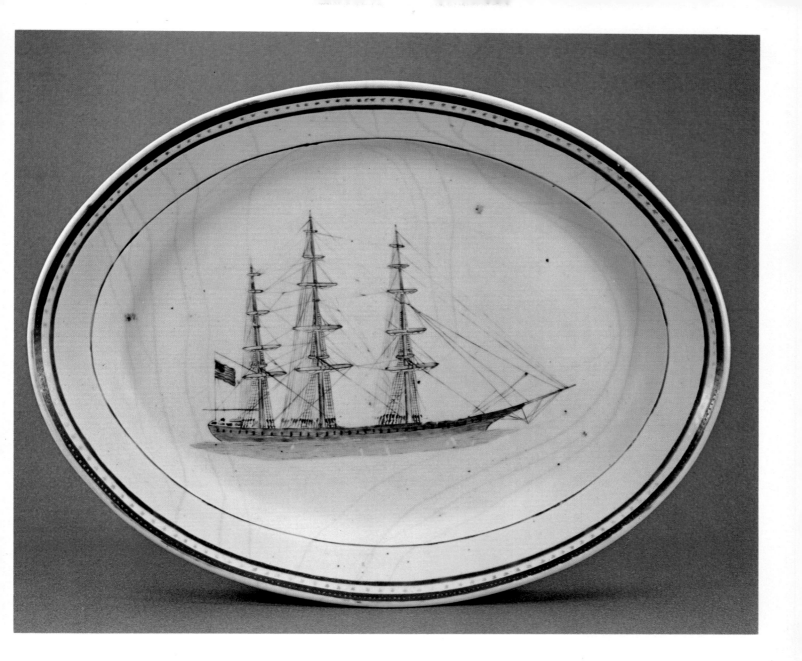

THE SHIPS

228
Dish

c 1850, diameter 14½ in (36.7 cm)

The porcelain on this dish is coarse, which is not unnatural for a piece of this date, and there are some stained glaze cracks, caused almost certainly by its having been left in an oven. The dish has double narrow bands of enamel at the rim: the outer red (with tiny gold dots) and the inner blue (between, gold stars). This is the sort of decoration that could have been executed about 1800,

but this particular combination of colours is not otherwise recorded at that date.

The identity of the ship is not known, but her bow shape and the way she is masted and heavily sparred make it impossible to date her before 1850. The presence of sky-yards on all three masts is another indication that the original was no earlier than the 1850s and she is in every way an American clipper ship, accurately recorded in their hey-day.

There is every likelihood that this porcelain was made at Ching-tê-Chên between 1850 and the sacking of the city in the T'ai Ping Rebellion of 1853 (although other sources of porcelain were available). It would have been enamelled at Canton.

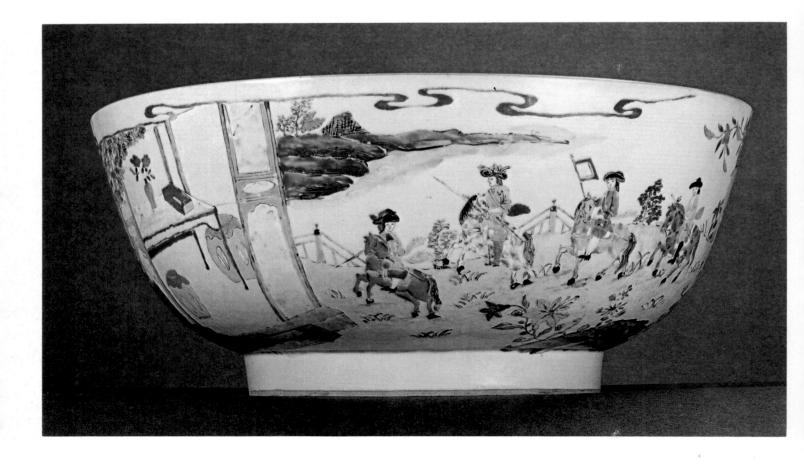

HISTORICO-POLITICAL DESIGNS

229
Punch-bowl
c 1755, diameter 15 in (38 cm)

The exterior is decorated with an elaborate and detailed cavalcade of European horsemen in the dress of the late seventeenth century. Sixteen in number, they are shown descending a rocky pass on their way to a Chinese 'retreat'. The first seven are clearly military, with the leading officers, swords drawn, riding strawberry and piebald horses, followed by an ensign with the Company's standard, two cavalrymen, a trumpeter and drummer.

The riders are colourful and include a number of carefully-drawn figures of the period. The leading officer may have been painted after a general of the late seventeenth century, the second in command is scarcely less well characterized. The two ensigns with colours are essentially the same horse and rider painted twice after the same original. This can also be said of the trumpeters. The drummer seems to be on parade while the most interesting of the merchants is the ninth in line, riding a bright chestnut, with a green parrot perched on his wrist, while he smokes (presumably a pipe, although this is not visible) with smoke being blown from his mouth.

The story of the Dutch Embassy to China in the early 1660s is told in great detail by Dr Olfert Dapper in *Gedenkwaerdig Bedryf Der Nederlandsche Ost-Indische Maetschappye op de Kuste en in pet Keizerijk Varr Taising of Sina* (published in Amsterdam in 1670). Although this book is profusely illustrated, none of the engravings could be the original for this scene although that on p 347 is similar.

The precise origins of the horsemen may be diverse, and collected from a number of engravings, for those bearing supplies or presents are difficult to place. However, it seems more likely that the Chinese copied a European print which showed a procession of some kind and adapted it freely to their own idiom.

The reason why they should do so remains obscure, however, it is just possible that it commemorates the centenary of the Dutch Embassy. Though for whom such an event should be commemorated and why, poses greater problems still. No other such bowl is recorded.

230
Six plates (*two illustrated*)
c 1722, diameter of each 6¼ in (15.8 cm)

Each plate with a border in underglaze blue, green enamel and gilt and a central scene similarly decorated with *rouge-de-fer* and black lettering. The series has six different plates as a rule although others may occasionally have been added.

The six inscriptions in Dutch are: *Wie op Uÿtrech of Nieuw Amsterdam* (Who wants to speculate on Utrecht or New Amsterdam)
Schÿt Actien en windhandel (Shares and Swindle)
50 per cent op Delft Gewonnen (Fifty per cent profit on Delft)
Weg Gekke Actionisten (Away foolish shareholders)
De Actiemar op de tong (The march of the share values played on the tuning fork)
Pardie al myn actien kwyt (By God, lost all my shares)

The series has come to be known as 'Het Grote Tafereel de Dusaasheid' (The Great Scene of Folly), and at least three other similar series are known, two with predominantly *rouge-de-fer*

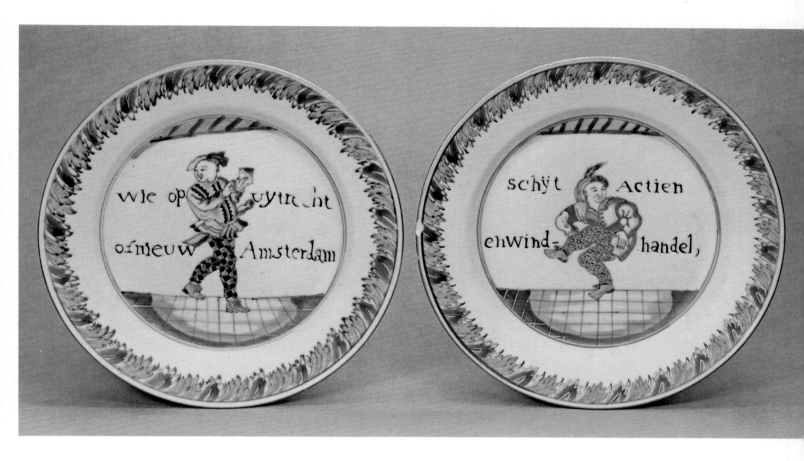

borders of 1725–35 (one with captions and the other without) and a later one with honeycomb diaper and butterfly border.

The *Commedia dell'Arte*, or 'Italian Comedy', figures from which are depicted on these plates, had as a main characteristic a largely unscripted dialogue during the time that it flourished from 1550–1750. It relied on sarcasm, wit and slapstick, with antics and buffoonery to give its message and raise its laughs.

In 1719 the *Commedia dell'Arte* reached a peak of popularity with its important role at the entertainments in Dresden for the marriage of Frederick Augustus (later II) to the Archduchess Maria Josepha, daughter of the Kaiser, and it is no coincidence that its players should have been shown on porcelain about 1722 when so many drawings and engravings were current.

The most remarkable five-year period of financial adventure in the history of Europe came to an end in 1721, and although in England the upheaval of the South Sea Bubble and a great many smaller speculations left their scars, they were nothing by comparison with the story of John Law, the son of an Edinburgh goldsmith who trained in London, Amsterdam and Genoa, and had long tried to interest financiers in his national system of finance.

It was not until the Duc d'Orleans became Regent of France, at a time when the French National Debt was causing great concern, that John Law found an opportunity to influence events through the Duc, who thought his ideas attractive. In particular, he proposed a paper currency based on land and the whole wealth of a nation.

In May 1716 he received official permission to found a National Board with notes to be legal tender for paying taxes. In 1717 he acquired the commercial monopoly of the merchant Antoine Crozot for developing Louisiana and the basin of the Mississippi, then owned by France. This company was financed with the new notes and by 1718, the notes became legal tender throughout the country, giving the Regent sole power to create unlimited 'wealth' by printing more currency. In December 1718 Law purchased the Senegal Company, and in 1719 the French East India Company, the China Company and the Company trading to the Bombay states. Early in 1720 he also bought the San Domingo and Guinea Companies – the whole enterprise now being called 'The Company of the Indies'.

So great had speculation in the Company's shares become that, in spite of the considerable opposition, Law was able to place on the market vast numbers of shares which rose very rapidly in value.

But the unpleasant truth was now dawning on investors that 12 per cent interest on 500 livres was not a satisfactory return on 12,000 livres. Frantically, Law worked through 1720 to stem the doubts that poured in. He raised the dividend to 40 per cent, but in spite of this and his courage in remaining in control in Paris, his system was in ruins by the end of the year.

Unlike some of his imitators, Law was a man of real integrity who believed passionately in his creation. He was cool-headed and brilliant in a crisis and his system hit hard at many of the gross injustices of the day. He died in exile in Venice in 1729, still absorbed in his plans for the future.

The question remains – what was the purpose of these series of plates? It seems likely that they were intended as a cautionary tale (rather than a commentary) for Dutch speculators, against trying any similar plans in Holland and thus putting at risk the hard-won profits made by trading. 'Who wants to speculate on Utrecht and New Amsterdam?' – 'Shares and swindle'! – 'Away foolish shareholders'!; but rather suggesting it was possible to achieve a reliable 'Fifty per cent profit on Delft'. The result for the incautious would certainly be 'By God – lost all my shares'.

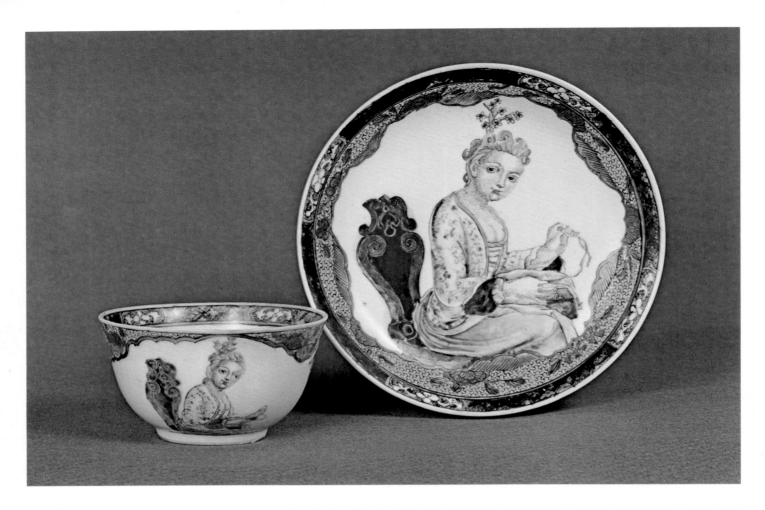

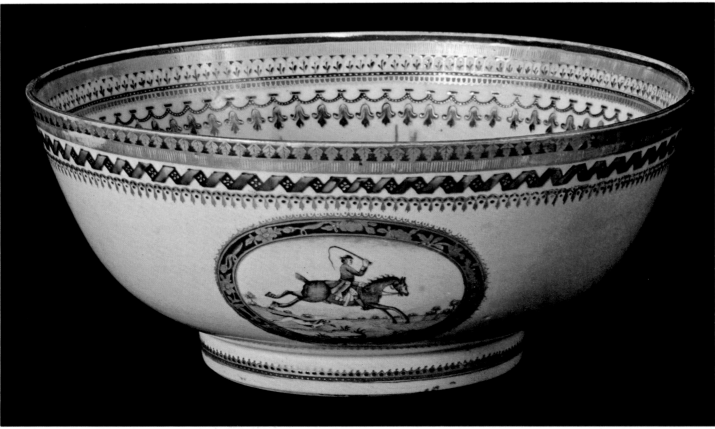

SCENES FROM DAILY LIFE

271
Cup and saucer

c 1735, diameter of saucer 4⅝ in (11.7 cm); diameter of cup 2¾ in (7 cm)

Decorated with a sepia and gold border with four floral reserves and encircling a scroll-edged band painted with Y-diaper work in blue, enhanced with gilt flowers and scrolls. In the centre, in carefully-chosen muted and natural colours is a seated lady embroidering a canvas stretched on a small frame held on her knee.

Her chair, her dress, and even the sprig of flowers adorning her hair (although misunderstood), proclaim the original to be a coloured, probably French or Flemish, print of about 1725–30. She may also be Dutch, and in the *Bulletin of the Museum Boymans*, a cup and saucer from the same service is illustrated and called 'Rachel aan de bron'.

282
Punch-bowl

c 1800, diameter 10½ in (26.7 cm)

Decorated round the rim both outside and inside with a complex border of enamelled bands, twisted ribbons, festoons and spearheads in predominantly dark-blue enamel and gilding, and at the foot with a narrow band which reflects this. On two oval vignettes are scenes of horsemen in hunting dress, one riding at a five-barred gate and the other, with whip raised, 'in full cry'. Each within a band of blue enamel gilt with leaves and tendrils.

The style of these vignettes is stiff, and peculiar to a number of such scenes on hunting bowls and to similar vignettes with one or two racehorses. The only known bowls with certain provenance are of American origin – e.g. that made for Samuel Spragg, Governor of Maryland between 1819 and 1822; for Captain Samuel Morris, 'President of the Gloucester Fox Hunting Club of Philadelphia' and the racing bowl made for John Seawell of Gloucester County, Virginia. It is of interest, too, that this type of bowl is found mainly in America, and the intervening ovals on larger bowls often contain a scene of the Delaware River.

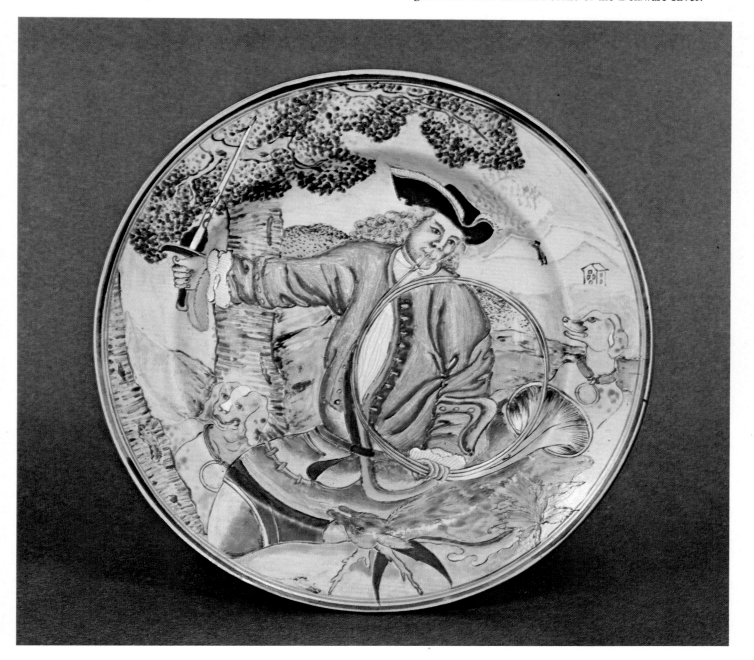

Plate *(see illustration on previous page)*
c 1740, 9 in (22.8 cm)

Painted in rich enamels with a huntsman sounding a horn and holding a hunting dagger in his right hand. On either side is a hound and in the foreground, distorted by a misunderstood perspective, is a stag's head with antlers towards the rim.

The dress and style of design are German, *c* 1730, and the figure and hounds match almost exactly a print by Johan Elias Ridinger (1698–1767) (Thienemann, *Johan Elias Ridinger* (Leipzig 1856, reprinted 1962), 67, also illustrated in the Catalogue of an exhibition held at Augsburg, May to September 1967, illustration 10).

Ridinger was a prolific artist who repeated many of his figural poses in several engravings. No doubt an exhaustive search would reveal the *exact* original, but the print cited is very close.

A coffee-pot of the same design (but probably not the same service) was formerly in the W. Winkworth Collection.

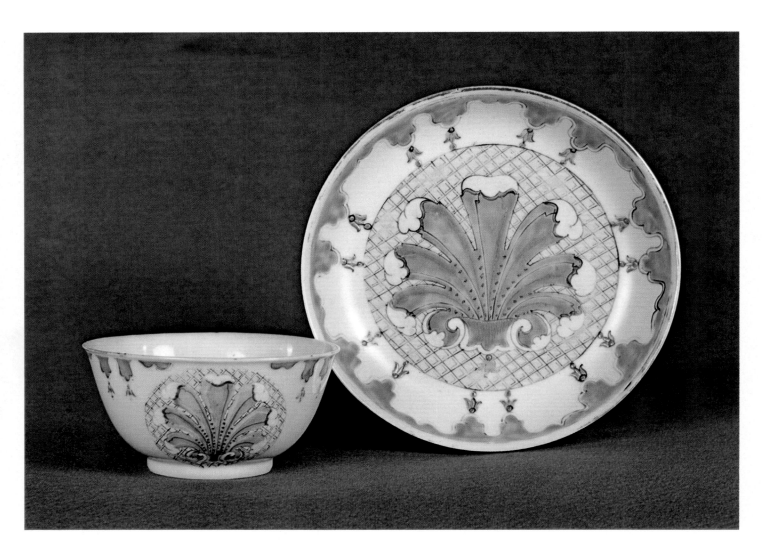

CORNELIS PRONK (1691–1759)

296
Cup and saucer
c 1736, diameter of saucer 4⅞ in (12.3 cm); diameter of cup 3⅛ in (7.9 cm)

Decorated in yellow and a semi-translucent violet enamel outlined and delicately shaded in black. In the centre the yellow ground is criss-crossed with pairs of diagonal lines *en grisaille*, so painted to give the appearance of a mesh or grille in perspective.

On all known pieces of the tea-service, the central plume of feathers or acanthus-leaf design is finely painted to give it substance and perspective, and there is every evidence of the most careful design, suggesting that an original *painting* was sent to China: otherwise the fullness and richness of enamelling would most probably be lacking. The grille-like lines are similar in design and execution to those on a vase in the British Museum.

There is little doubt that this design emanates from the design workshop of Cornelis Pronk, and to judge from its freshness and spontaneity it is an early pattern. Possibly all the recorded pieces of this type would add up to little more than a large tea-service (which often had three teapots). This may be due to difficulty in firing the violet enamel. (See p 23 for the story of Cornelis Pronk).

Seven pieces of this service (Williamson, pl XVIII in colour); other pieces, Victoria & Albert Museum; small part service: Metropolitan Museum.

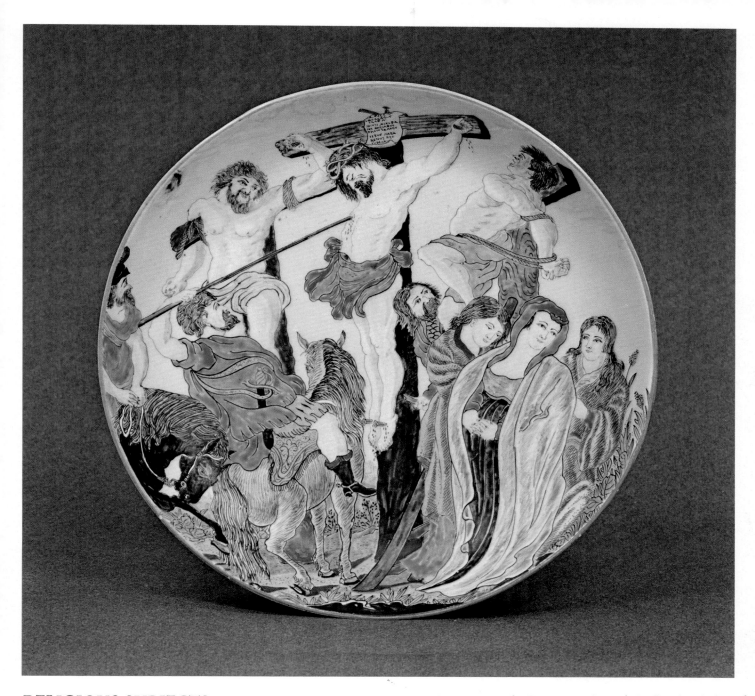

RELIGIOUS SUBJECTS

307
Saucer dish
c 1735, diameter 8¼ in (21 cm)

Painted in an unusual palette of enamels with a scene of the Crucifixion after Rubens. On the cross above the head of Christ is written in Hebrew and Latin 'Jesus of Nazareth, the King of the Jews'.

Considerable discussion has centred on this dish and another almost identical to it in the Victoria and Albert Museum, and the painting has as frequently been considered Dutch as Chinese, the enamels being unlike those normally used by the Chinese at that time.

It would be difficult or impossible to resolve this question from examination of these two dishes alone, for the similarity between the Chinese copy of a European print and the Dutch painting of the same scene is considerable. It is only when comparison is made between the colouring on this plate and a number of similarly-coloured Chinese porcelains in the same gallery at the Victoria & Albert Museum that the solution becomes clear.

Making every allowance for the fact that the Chinese might have been copying a Dutch-decorated original, they would not or could not have introduced into their palette special colours, even for such an important piece as this. The short green tunic of the horseman with a spear, the red shading on yellow or on violet of two robes to the right, and the muddied crimson shadows of the horse's hooves are not in the Chinese repertoire, while they occur in other pieces which are certainly Dutch-decorated. Almost as important, the blades of grass in the foreground, the foliage in the middle distance and the green leaves on the right show definite Dutch treatment. The conclusion that this piece is Dutch-decorated is inescapable.

Another example: Victoria & Albert Museum.

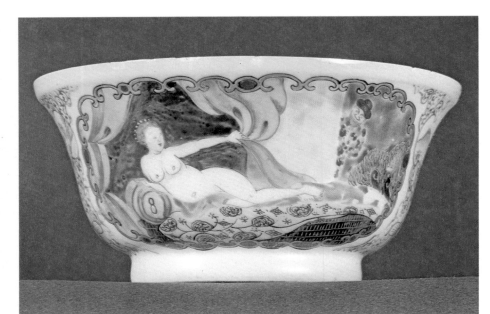

342
Bowl
c 1750, diameter 4¾ in (12 cm)

Painted in bright *famille rose* enamels, the two panels divided by gilt scrollwork enclosing small oval landscapes *en camaieu*. A seductive naked lady, stretched on a bed, draws back curtains to see (and be seen by) her visitor, Harlequin.

Although clearly Harlequin derives from the Italian Comedy this scene is not a recorded part of the *Commedia dell'Arte*, and it perhaps represents a specially-commissioned Chinese version of this most popular character in his role as the indiscreet 'Peeping Tom'. Kaendler models of about 1740 show him observing lovers (as do later models at Bow, *c* 1753), and it was no doubt a natural development that he should be added to the repertoire of the Chinese painters.

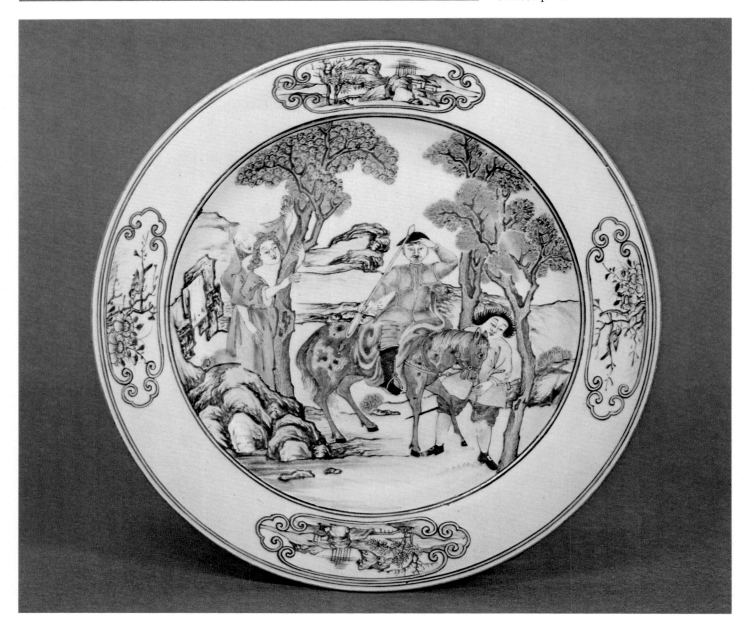

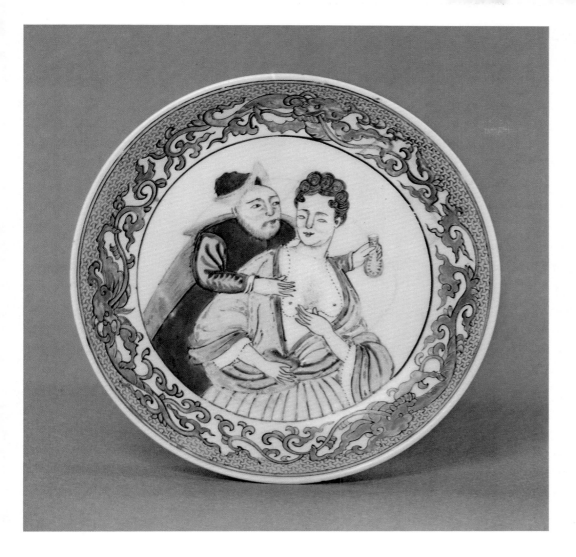

344
Plate
c 1750, diameter 9⅛ in (23.2 cm)

Painted predominantly in *famille rose* enamels, the scene is drawn within a plain border with four cartouches of Meissen shape containing alternately *grisaille* Chinese landscapes and birds.

The scene itself is redrawn by a Chinese artist after a porcelain service of some years earlier (plate, *c* 1742, formerly in the Martin Hurst Collection, now in the Western Reserve Historical Society). It shows Don Quixote riding a horse led by Sancho Panza while two laughing girls watch from behind a tree. The compositions are the same, although the head of Sancho Panza's kneeling donkey is present in the earlier version. It is an interesting example of the transformation of the original engraving into a scene which appears almost Chinese in character.

Lunsingh Scheurleer shows that the earlier service is copied faithfully in almost every detail from an engraving by J. Folkema (1692–1767) entitled in Spanish 'D. Quixote toma la Bazia de un Barbero, por el Yelmo de Mambrino' (Vol I, p 212) (Don Quixote dons a barber's bowl as Mambrin's helmet). The only feature missing is a man running away in the background. This engraving derives in turn from an engraving by B. Picart (1673–1733) after a painting by C. Coypel – illustrating an earlier edition of *Don Quixote* – which is very similar, but does *not* show the two laughing girls. (The Dutch translation of this edition was published in The Hague by Pieter de Hondt in 1746, but the earlier Spanish and French editions had by then been in circulation for two decades, while Folkema's engravings had been

current since 1741.) Coypel's original painting had thus been adapted four times (in Picart's engraving, Folkema's engraving, the *c* 1742 porcelain version, and that illustrated here) to reach its present form.

PICTURESQUE SUBJECTS

357
Saucer
c 1738, diameter 4½ in (11.4 cm)

Still much in the Yung Chêng style, this saucer may have been made as late as 1740. The porcelain is of eggshell quality, and decorated with fine Y-diaper in turquoise-blue and Chinese scrollwork in gold.

Williamson illustrates this saucer (pl XLII) and with kindly eye describes it as 'with a love scene, a gallant, wearing blue and red cap, *rouge-de-fer* coat, with aubergine sleeves and grey cape, has his hands round the lady, to whom he is apparently offering a flagon of wine.' A less chivalrous view is that the man is dressed as a merchant on his journeys, and that the 'flagon' he proffers is carefully stitched and almost certainly contained gold, while the lady seems about to succumb to his alms.

There can be no doubt of the European source for she has surprisingly European features, but his robes are more appropriate to an Italian than an Englishman or Dutchman.

From the Martin Hurst Collection, Cat 165.

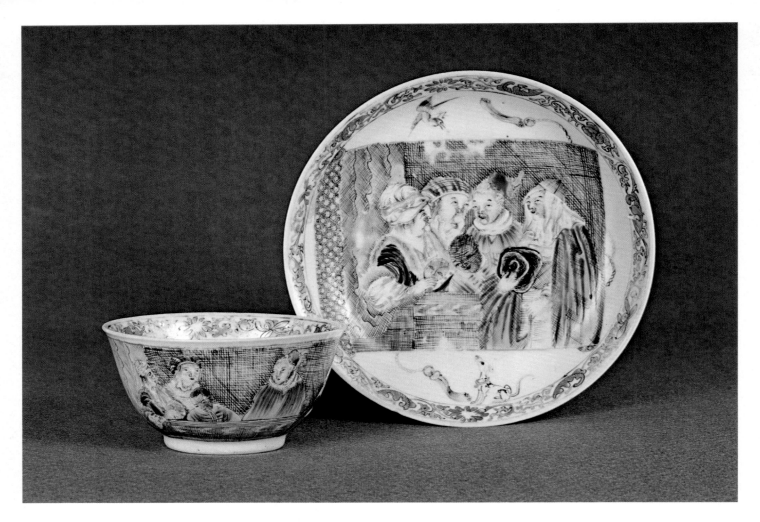

363
Cup and saucer

c 1740, diameter of saucer 4¾ in (12 cm); diameter of cup 2⅞ in (7.3 cm)

Within a rim of gilt scrollwork, a scroll is unfurled bearing a scene painted in enamels on a ground shaded *en grisaille*. Above, a bird hovers encouragingly, while below a hound looks up hopefully.

The scene on the porcelain is reversed after an engraving by Thomassin entitled 'Coquette pour voir galants au rendezvous' (The coquette meeting her admirers), after a painting by Watteau of which the original is in the Gallery at Gatchina. The coquette, here on the left (but originally on the right), is gazing itently at the shy young gentleman in the centre (bowing before whom is the black boy). Between them a middle-aged man laughs gaily, while on the right an elderly (wealthy) merchant watches the girl intently. Perhaps she is expected to choose; perhaps her heart and her head give conflicting advice?

In attempting to reproduce the whole effect, the Chinese painters have lost delicacy and simplicity so that it is not very clear which are the men and which is the girl, which is the black boy and which the mask.

A more successful Meissen version of *c* 1735 (also in reverse) is illustrated by Ducret (*Meissner Porzellan* (1972), Vol II, fig 196): this also suffers from poor draughtsmanship in the translation of print to porcelain, but it avoids the pit-fall of the heavily drawn 'etched' background on the Chinese version. It is there known as 'Le Retour du Bal'.

From the Martin Hurst Collection.

The original print illustrated Lunsingh Scheurleer, pl 219.

SERVICES WITH PORTUGUESE ARMS

375
Porcelain dish and pair of enamelled goblets

c 1735, length of dish 17½ in (44.8 cm); height of goblets 7 in (17.7 cm)

The porcelain service is decorated over most of its surface with moulded scrollwork, perhaps in imitation of the much admired *an hua* ('secret decoration') of Ming and earlier. The border is in early *famille rose* enamels enriched with *rouge-de-fer* and gilding. The arms are encircled with gold scrollwork with an angel's head at either corner and surmounted by a noble's coronet. At the well is a gilt diaper border of a type popular on services of mid Yung Chêng date.

The enamelled copper goblets are rare indeed, and are plainly decorated on an opaque white background imitating porcelain. They have a delicate spearhead design at the rim and gilt scrollwork on the collared stem. It is possible they may be of a later date than the dish (although this is not certain, and if shown to be contemporary they might well be the earliest known armorial enamel). The arms are as elaborate as on the porcelain, but the tinctures are not all the same and where this is the case, are painted with varying intensity.

The arms are of I, Pereira; II, Pinto; III, Guedes and IV, Pimentel, within a bordure, and this is one of three known services on which these arms appear. It is sad that with such beautiful and magnificent services the owner has not yet been identified.

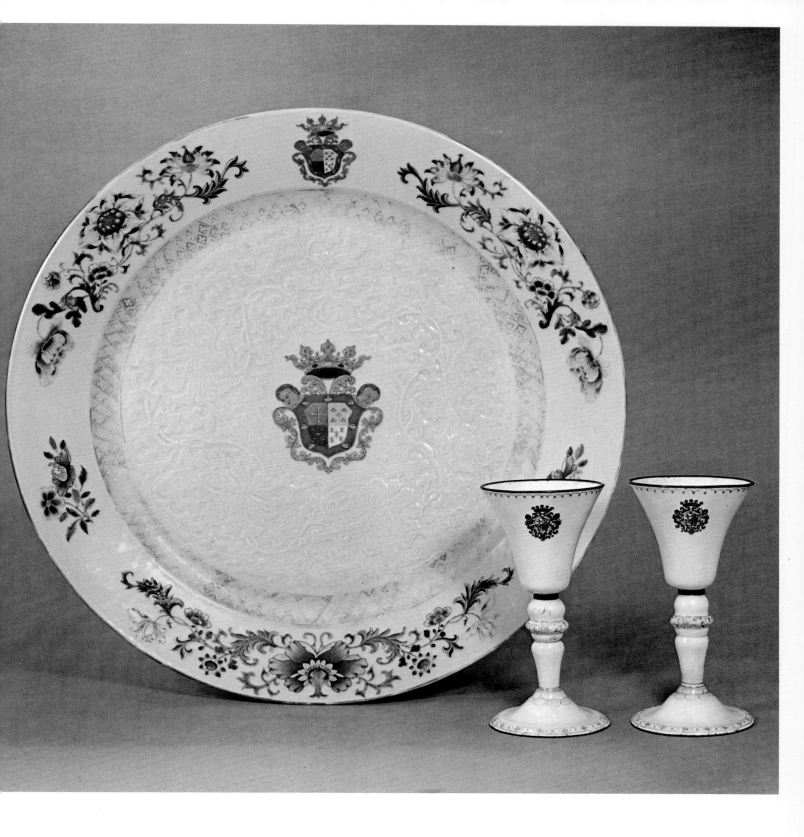

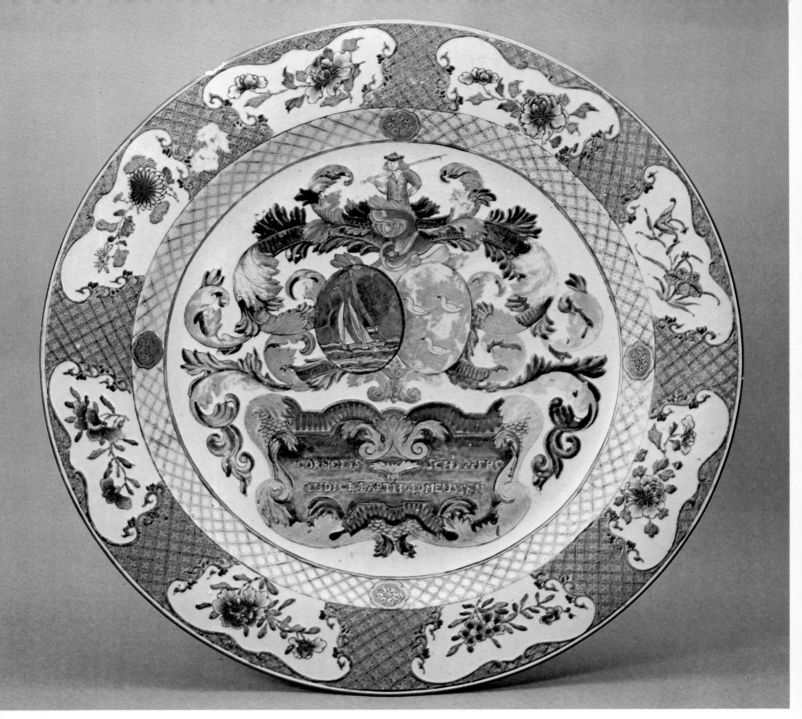

SERVICES WITH DUTCH ARMS

389
Dish
c 1733, diameter 15 in (38 cm)

This service is the most richly decorated of any armorial service made for the Dutch market.

On this dish the eight reserved panels on a rim of rose-pink diaper are similar in palette and period to the service made for the British market with the arms of Jephson impaling Chase. The central design is remarkable for the use of both gold and silver (now much tarnished) with the most pleasing and sparing addition of rose-pink. A comparison between the beautifully-painted crest and helm on this service and the clumsy work with rose-pink enamels a decade earlier shows how far the control of this new palette had advanced. The two oval shields are painted with a

remarkably modern-looking yacht-like vessel, almost certainly a coastal lugger painted from its most graceful angle, and with three birds, and below these arms is a panel reading *CORNELIS SCHIPPERS JUDICK BARTHOLOMEUSON* (there can be little doubt that the Schippers' arms are a pun on the name – although Rietstap records Schippers of Gouda bearing *Argent a stag passant sable* and Schippers 'of Holland', *Sable en anchor argent*).

There is an equally beautiful tea-service with crest only and the intials *C.S.* and *J.B.* in adjacent shields. The border is pink with gold diaper work broken by four reserves of Meissen shape decorated with flowers.

From the Martin Hurst Collection.

Other examples: similar dish, Museum Boymans, Rotterdam; cup, Henry Francis du Pont Winterthur Museum.

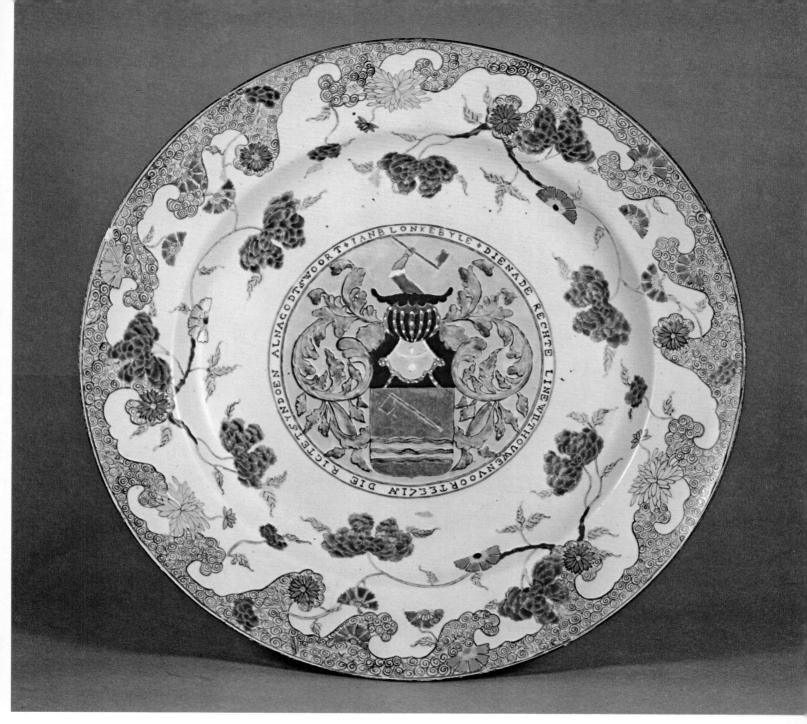

390

Dish

dated 1733, diameter 15½ in (39.3 cm)

Painted on the rim with a continuous wave-like border of sepia
scrollwork with sprays of yellow chrysanthemum and rose-pink
peonies, and other blue and gold flowers. On a central medallion
with pale yellow background is a coat of arms with helmet and
crest and rich green mantling.

Surrounding the coat is the partly obscure legend
DIE RIGTE SYN DOEN ALNA GODT SWORT/JAN

*BLANKEBYLE/DIENADE RECHT LINE WILTOU
WENVOORT/AV 1733* which should probably be translated: 'Jan
Blankebyle – He lives by the word of God – the direct
descendant of Wilton Wenvoort – AD 1733'.

As far as is known no other piece of this service has been
recorded; but there seems every reason to think that the date is
the year of manufacture. This type of scrollwork, more popular
perhaps in the Middle East than in Europe, was used on Yung
Chêng porcelain (c 1730–40) and another armorial service which
incorporates this, though differing in form, is that made for the
Huguenot family of Grand-George.

No arms are recorded for Blankebyle.

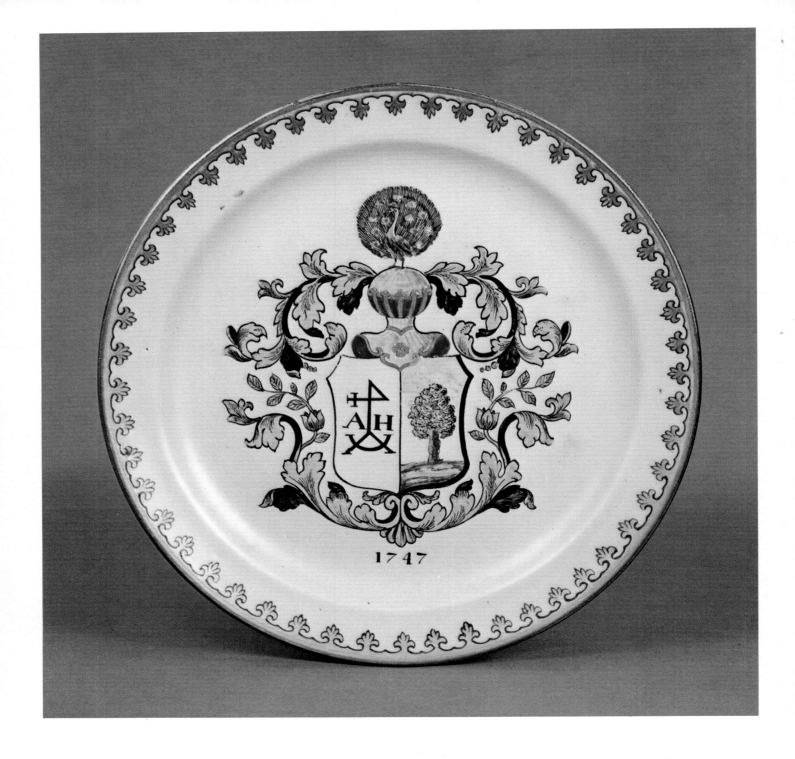

400
Plate
1747, diameter 9 in (22.8 cm)

Decorated on the rim with an ample gilt spearhead border and in the centre with an interesting shield in predominantly green enamels.

This is one of two remarkable services made in successive years for Hendrick Hesselink (or for two brothers Anton and Hendrick). On the sinister side of the shield are the arms of van Hesselink as recorded before 1748 *On a mount, a tree all proper*; crest *A peacock displayed proper*. (In 1748 the arms were altered and bore three trees.) The dexter shield displays a merchant's mark with the initials A.H. These were possibly incorrectly painted

– a badly written *H* could easily be mistaken for an *A* – and corrected the following year, for a service dated 1748 exists bearing the initials *H.H.* (As this is only known on pieces of a tea-service however, it may have been a companion to this dinner-service.)

Hendrick Hesselink was born in July 1723 and died on 21 January 1780. He occupied a post equivalent to that of poor-law commissioner at Doetinchen in Gelderland, and married twice, the second time in 1766 to a Miss Keppel and there is still a Dutch family of Keppel-Hesselink. The Arnhem branch of the Hesselink family still bear the peacock crest.

Other examples: cup and saucer, very similar but with initials *H.H.* and date 1748 (Williamson, pl XXXVII).

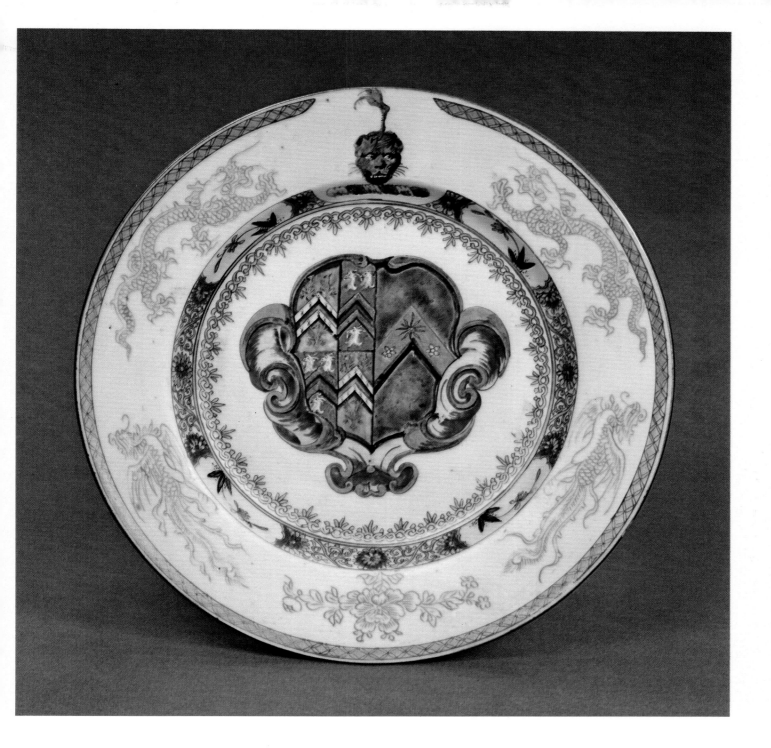

SERVICES WITH BRITISH ARMS

410
Plate
c 1722, diameter 9 in (22.8 cm)

Painted with dragons and phoenix in underglaze blue round the rim and with bands of *rouge-de-fer* and gold scrollwork and diaper borders round the well. Eight such services are known marking the transition in armorial porcelain from underglaze blue to the enamelled ware, none of which includes a trace of rose enamel.

The earliest has a crest only on the rim and a *famille verte* treatment of the centre and the present service with the arms of Parsons impaling Crowley may be the latest of this style.

Sir Humphrey Parsons, M.P., who was twice Lord Mayor of London – in 1731 and 1741 (during which mayoralty he died) – was a very wealthy brewer who, unusually for that date, was a favourite of King Louis XV, and he was given special permission to import his own beer into France free of duty so that he might drink it there while on visits to the French Court.

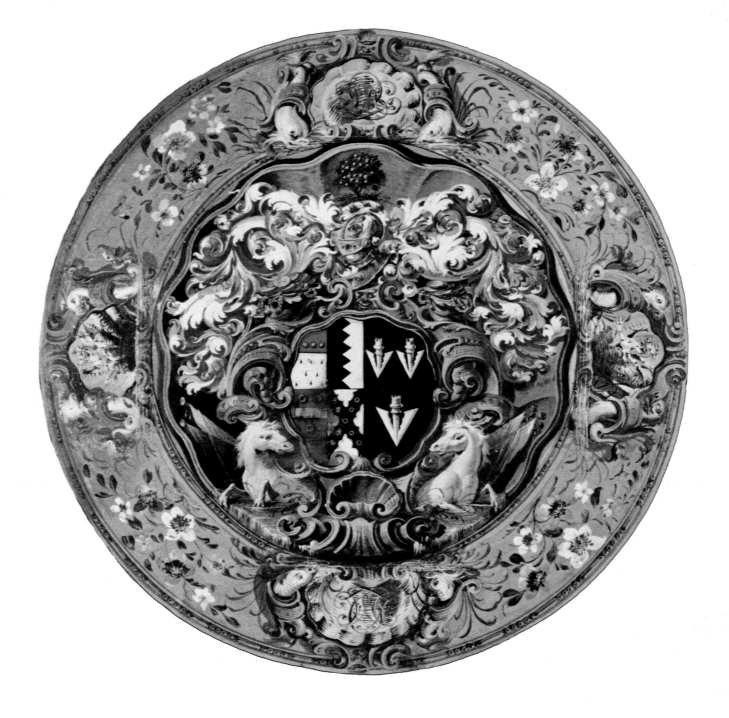

413
Plate
1740 or 1743, 9 in (22.8 cm)

Magnificently enamelled in a wide range of *famille rose* colours copying minutely a coloured painting sent to China (*opposite*). There is no trace of Chinese design in this service and every stroke, down to the bends in the blades of the water reeds, is a faithful mirror of the original. There are two variations from the pattern: first, the original was painted on a dull buff background (almost as if the local(?) painter did not know of the white porcelain that was then flowing into Europe), and secondly, the

scalloped effect of the whole central ground, which is shown clearly on the pattern, has not been translated on to the plate. These two differences apart, the reproduction is exceptionally accurate and marks out this service as one of the finest ever made.

The provenance and documentary evidence are scarcely less interesting. The quarterly arms are of Leake Okeover, born 1702, and impale those of his wife Mary Nichol whom he married about 1730. On the rim are four reserves with his crest and their cypher *L.M.O.* It must have been in 1738 that he first ordered a service of porcelain from China, sending a painted pattern with the words on the reverse *The Arms of Leake Okeover Esqre. of Okeover near Ashbourn in the Peak in the County of Derbyshire – a pattern for China plate. Pattern to be returned.*

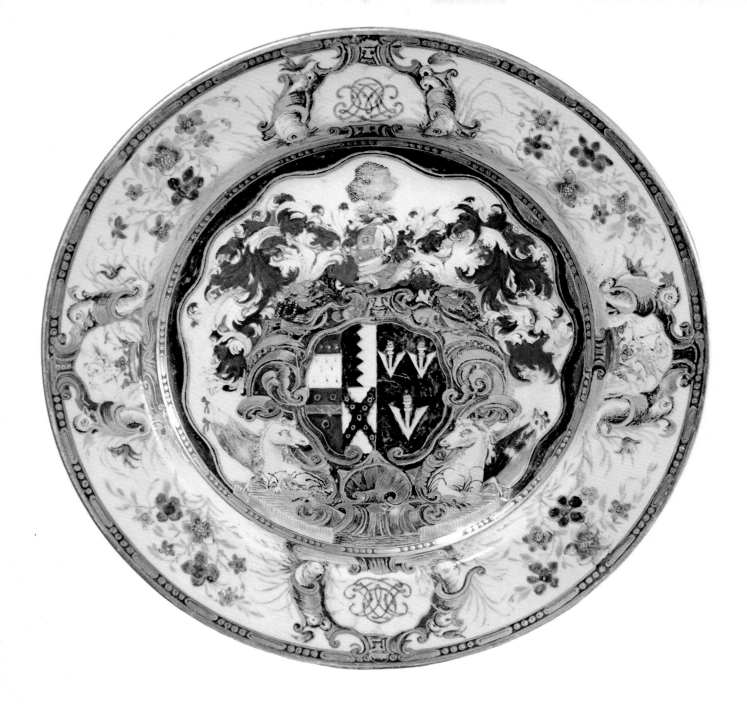

In 1740 and 1743 two deliveries were made. The first is dated 16 January 1740, listing '70 Plates and 30 Dishes', which with duties and boxes cost £99 11s. 10d, and signed Ralph Congreve. The second is dated 1743, reading 'from ye Jerusalem Coffee House, Change Alley, a consignment of fifty plates and four large dishes with your arms'. It is addressed to 'Leake Okeover Esqre.' by Ralph Congreve, Commander of the Ship Onslow. Thus a total of not less than 120 plates and 34 dishes were delivered but, as far as is known, no piece of another shape. The price of £1 each reflects their very high quality and may be compared with the prices of the two services delivered to Charles Peers a decade earlier. (Blue-and-white service average one shilling; *famille rose* average three shillings).

Leake Okeover died in 1765 without an heir, but the estates, as well as these documents, are still in the possession of his family. Over the years a very small number of plates have left the family and in March 1966 a perfect specimen was sold at auction for the then surprising price of 580 guineas. In March 1975 a hundred pieces, dishes and plates, of which more than half had some damage, were sold by Sir Ian Walker-Okeover Bt for almost 58,000 guineas, thus confirming an appreciation in value of at least six hundred times over the two hundred and forty years (although the currency is probably worth about one sixtieth of what it then was). Fortunately, the care with which this service was designed and then painted in China is matched by the care with which it has been treated since.

A similar plate: *Chinese Armorial Porcelain* frontispiece and p 398.

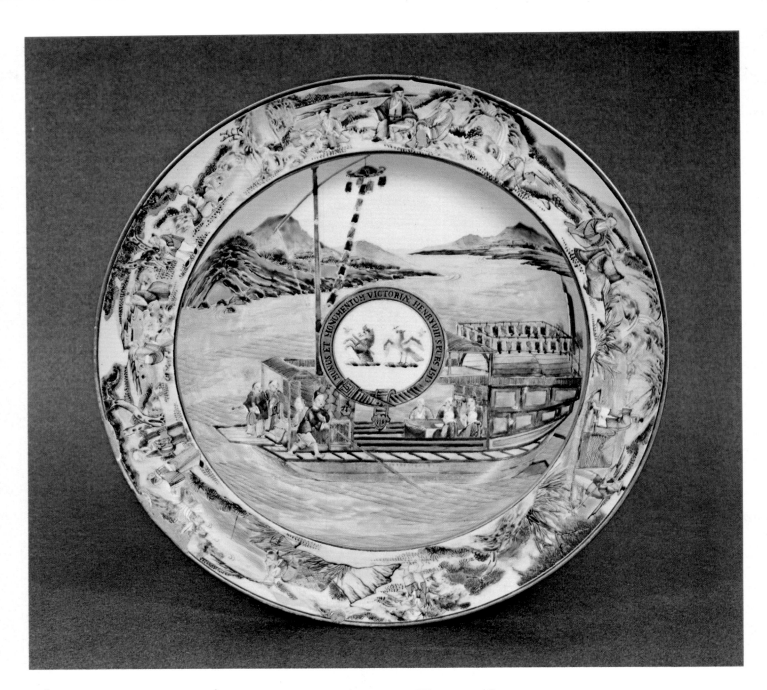

446

Soup-plate

c 1813, diameter 10 in (25.3 cm)

Brightly painted in enamels with a boating scene. In a vivid turquoise sea a Chinese two-tiered, gondola-like boat is being propelled by a long oar, while five Chinese gentlemen sit at a table amidships under a canopy. In the bows is a three-piece orchestra, with drum, gong and cymbals. The rim also has scenes along a shoreline. The atmosphere seems to be one of a pleasure cruise through one of the many channels which lead to Canton. It is possible that it represents the journey from the anchorage at Whampoa to Canton.

The two crests in the centre are of Clerke, and about them is a ribbon with the inscription *Munus et Monumentum Victoriae Henry VIII Spurs, 1513*. This recalls the victory of Henry VIII at the Battle of Spurs in 1513. At the battle Sir John Clerke of Weston took prisoner the Duc de Longueville, and this service almost certainly commemorates the three-hundredth anniversary of the battle. The same family had an earlier Chinese service made about 1730.

This service was made with a considerable number of variations of design. One piece is entirely painted with fish in rigid postures (clearly dead!) and another with butterflies and birds.

64

SERVICE WITH AUSTRIAN ARMS

460
Dish
c 1740, diameter 13½ in (34.4 cm)

Decorated with a border design executed in blue enamel and gold, but clearly after a similar design *en grisaille*. The broad use of colour here defeats the subtle rococo design, which follows the style associated with the du Paquier factory in Vienna. The four breaks in the rim design are filled with quivers and arrows and (probably) emblems of music – although if a lyre is intended it is almost unrecognizable.

In the centre, within a meandering rococo frame is a magnificent coat of arms with crest, coronet and supporters above

a broad green compartment. The arms have not been identified with certainty and this is less surprising than might be expected, as another service of *c* 1740, has the same arms, supporters and crest, but in entirely different tinctures and with a different coronet. There may well be other errors.

The nearest coat is, in fact, Austrian, of the family of Krueger, and the coronets on both services could be intended for those of 'untitled nobility'. The Krueger arms are recorded as *Or, two bars sable, over all on a bend gules a unicorn courant argent*. The crest, too, would be correct: *A unicorn 'issuing'*.

It would be of interest to discover if any merchant of the Imperial factory at Canton had this name. (Until now, the service has frequently been thought to be for a Swedish family, but careful research has failed to confirm this. However there are a number of these plates in the Sällskapet (club) in Stockholm although the arms are unknown there.).

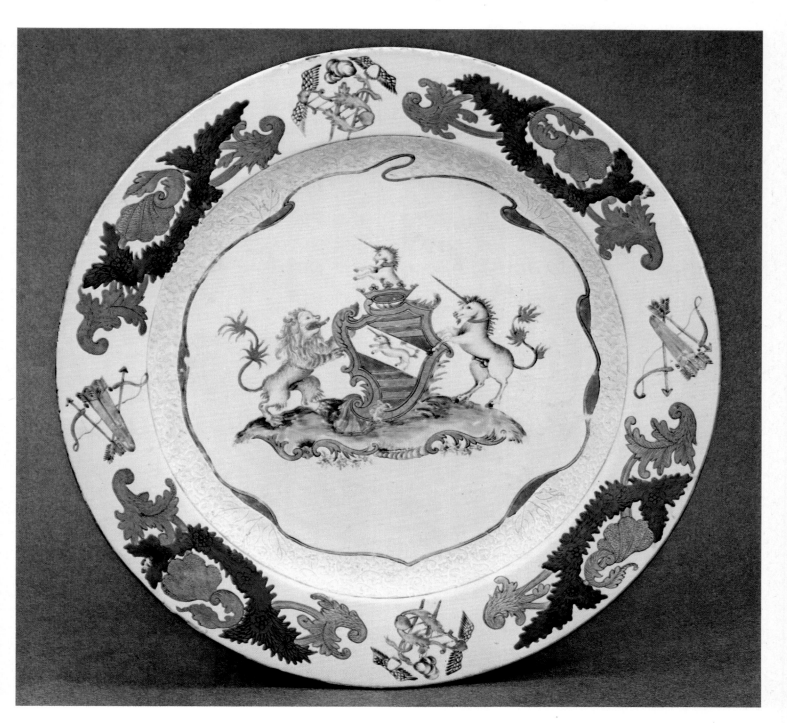

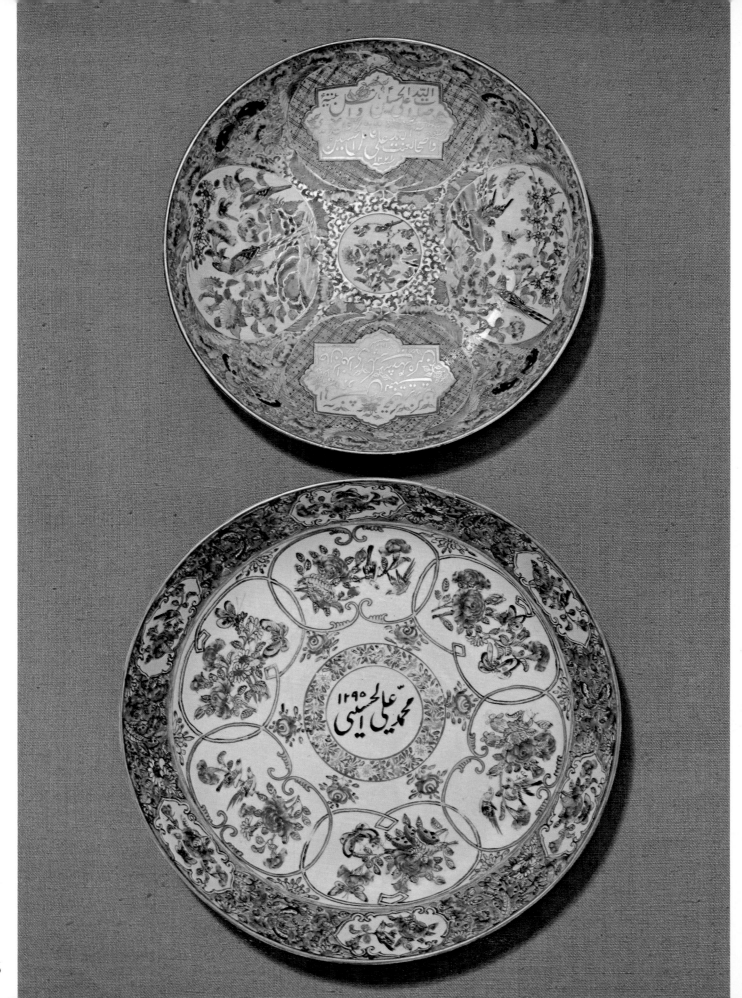

PORCELAIN FOR THE NEAR EASTERN AND INDIAN MARKETS

496
Saucer-dish
Dated 1854–55, diameter 8¾ in (22.2 cm)

Painted in brilliant enamels reminiscent of the Yung Chêng period, on porcelain of good quality, but with a footrim quite unlike the contemporary service made for Shah Nasir'ud Din, being very shallow and of dirty-white appearance. On a background of gold, green and rose, with butterflies, there are four large panels surrounding a small central one of a bird among carnations. On either side are two larger oval panels with blossom, small birds, and pheasants, and above and below shaped rectangular panels on turquoise trelliswork. These panels are finely gilt with inscriptions in Arabic and Persian, painted with some precision in China but with minor errors which make it clear that the calligraphy is the work of a copyist. If the bird in the centre is assumed to be the correct way up the Arabic inscription above reads: 'The Salutation of God be upon Husayn and the members of his house and his followers. The curse of God be upon Yazid and his (Husayn's) enemies'. AH 1271' (the year which started 24 September 1854).

The Persian inscription below reads: 'Have a drink of water and invoke the curse of God on Yazid. Give your life as a sacrifice to the body of the martyred King. AH 1271.'

From the Afnan Collection.

497
Saucer-dish
Dated 1878, diameter 10 in (25.5 cm)

Of white porcelain with shallow, undecorated foot which is comparatively clean. Painted round the rim with butterflies and flowers in rose, green and blue on a gold background are six reserved white panels with flowers. About the centre are six overlapping panels encircled alternately by gold and grey 'cords' each containing flowers and butterflies or birds. Within this a tight band of flowers, and painted in the central roundel 'Muhammad Ali al Husayni, AH 1295' (the lunar calendar date for AD 1878).

Muhammad Ali al Husayni was the cousin of 'the Bab', this father having been the brother of 'the Bab's' mother. 'The Bab' himself was undoubtedly one of the most important religious figures in Iranian history. There was a widespread belief among Muslims that someone would arise to restore piety to their religion, and 'the Bab' appeared to fulfil this expectation, claiming great loyalty among his followers. The efforts of the Kajar Dynasty to repress the religion did not end with the death of 'the Bab' in 1850, and thousands of 'Babis' were put to death with great cruelty. These excesses only served to strengthen their faith and today the 'Bahai' religion, while still strongest in Persia, is rooted in many other countries.

Born in 1823, Muhammad Ali was a merchant of considerable standing who travelled widely from India (1851) to Egypt and Marseilles, and later to China where he became a merchant at Shanghai, supplying considerable quantities of porcelain to the Persian market. He is known to have visited Hong Kong in 1883 and 1890 and in 1896 was taken ill at Bombay where he died, his body being carried home to Persia for burial at Najaf.

Such was the feeling against 'the Babis' at that time in some parts of Persia that when his coffin reached Basra, an angry crowd tried to throw it into the sea, a plan which was thwarted by his family and friends who eventually buried him near Baghdad at the Shrine of Salman the Pure, the first Persian convert of the Prophet Muhammad.

510
Teapot
c 1798, length overall 10 in (25.3 cm)

Plainly decorated with two bands of 'imitation milling' at the mouth and edge of the lid, and with fruit finial and interlaced handle, this teapot epitomizes the simple, functional porcelain popular in America after Independence.

The eagle is firmly painted, with the initials *EHF* in a sepia which blends well with the orange and blue decoration. The origin of this eagle was the Massachusetts copper cent of 1787–88, but the sunburst was not used until the minting in 1796 of the gold 2½ dollar. There is no record of any tea-service actually commemorating the issue of this gold dollar, but had there been such services this teapot would surely have been in the right palette and style at this date.

This eagle was to prove the most popular of all those that decorated Chinese porcelain during the three decades that eagles were in vogue.

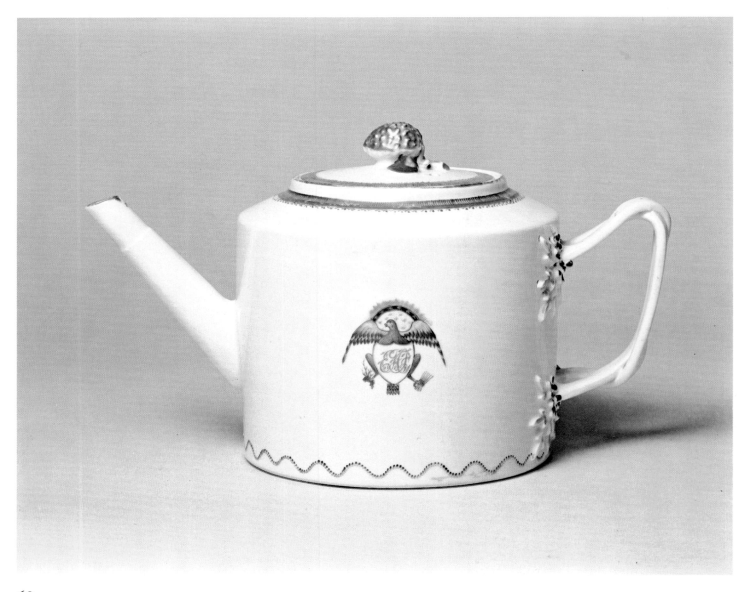

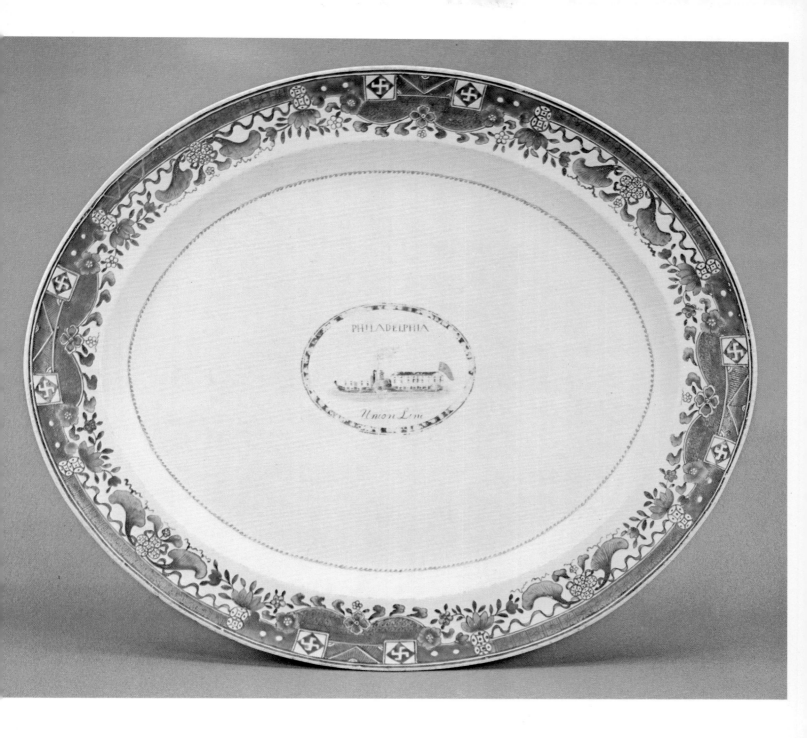

507
Dish
c 1825, length 17 in (43 cm)

Decorated at the rim in thick blue enamel with a design simplified from the 'Fitzhugh' border. Within this a narrow continuous band of dog-tooth decoration, and in the centre an oval panel with patterned edge painted with a paddle-steamer of the period with twin funnels and large covered after deck. Above, the word *PHILADELPHIA*, and below, *Union Line*.

The coastal and river traffic at this period was a very important form of transport, particularly near the great ports. (A generation later the Vanderbilt fortune was built on it.) The original of this painting is a document connected with the ship *Philadelphia*, launched in 1816, which normally sailed in the Chesapeake Bay

and the Delaware River and, it is thought, also made occasional journeys from Philadelphia to New York.

A porcelain service of this kind was probably less likely to have been used on board (for first-class passengers) than at an important stopping place – sometimes the principal hotel was owned by the shipping line – where it would serve as an advertisement for the line. However, the *Red Rover*, an English tea-clipper, is known to have used its service, made in 1823 of similar porcelain decorated in orange, for the officers on board. (That service is now in the Offices of Matheson's Bank in the City of London.)

Other pieces from this service: dish, Henry Francis du Pont Winterthur Museum; sauceboat and leaf-shaped sauceboat stand also in the Winterthur Museum.

THE EXCHANGE OF CERAMIC IDEAS – EUROPEAN DESIGNS

532
Plate
c 1740, 9 in (22.8 cm)

Decorated in *famille rose* enamels with in the centre a shepherdess caressing a lamb within a cartouche of Meissen shape. An incongruous border of Chinese gilt vine leaves and tendrils suggests that the original was a saucer, with no outer decoration to copy.

There is no doubt that the original of this service was Meissen porcelain painted in Augsburg by *hausmaler*. Ducret (*Meissner Porzellan*, vol II, p 306) illustrates just such a shepherdess (though with no lamb). Further search would almost certainly produce the exact original. The workmanship is so fine that there is hardly a trace of Chinese influence in the painting of the figure, which probably means that it has been copied in every detail at first hand.

The Chinese border illustrates that in the absence of a European original the painters usually fell back on designs they knew well rather than improvising in the style of the rest of the design.

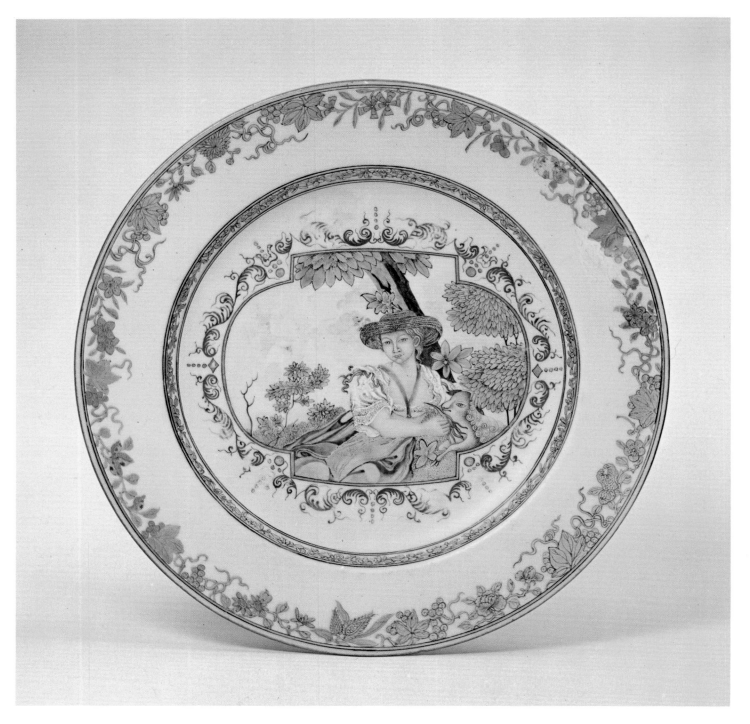

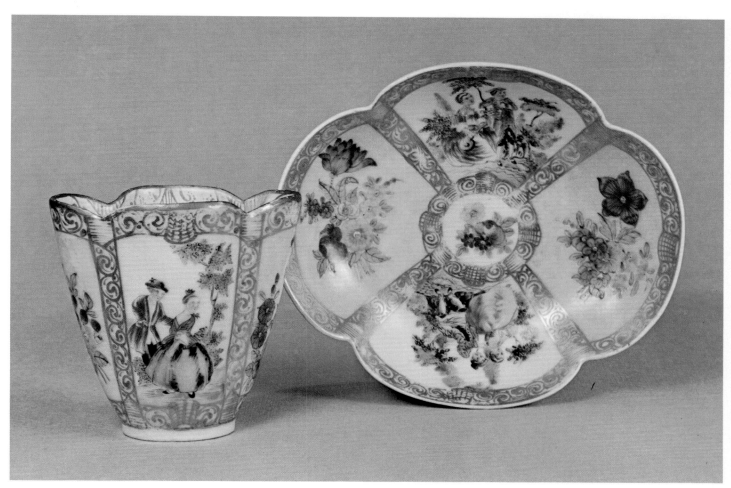

539
Cup and saucer
c 1865, diameter of saucer 5¾ in (14.5 cm); diameter of cup 3⅜ in (8.5 cm)

These are decorated with four panels in *famille rose* set on alternate yellow and white grounds and divided by bands of gilding somewhat in the manner of Meissen, but of a quality much inferior to either the European ware or most Chinese imitations. Within the shallow footring is the Meissen-style monogram mark: script *AR* (for Augustus Rex), as used between 1723 and 1736.

The panels are of Watteauesque subjects not introduced until after the 'crossed swords' became the official mark of the factory. Although at first sight it may seem that this cup and saucer could have been produced in China in the mid-eighteenth century, it is now clear that it is in fact a copy of a much later reproduction of the early Meissen ware, and the crude pattern of gilding inside the cup, in particular, lends support to this. At Dresden in the second half of the nineteenth century a number of decorators, of whom Helena Wolffsohn is perhaps the best known, decorated German porcelain in this style and made use of the *AR* mark.

Until recently only four Chinese cups and saucers were recorded of this shape and design, suggesting that the enterprise was not very successful. Further convincing proof of their late date has been found in a second cup and saucer from the collection. Shape, size and quality of porcelain are the same and the mark *AR* is painted on both the cup and saucer, but the design of Mandarin figures is set in a border of purely Chinese 'Canton' style of the middle to third quarter of the nineteenth century.

Other examples: pair of cups and saucers, Metropolitan Museum of Art, New York (Le Corbeiller, pp 92, 93); cup and saucer, Victoria & Albert Museum.

Cache-pot

c 1810, diameter 8 in (20.3 cm)

This cache-pot is decorated all over the outer surface with broad leaves in shades from pale turquoise to blue, veined and scattered with small flowers and with a focal rose-coloured flower.

This was possibly the last of the Chinese flower patterns of the eighteenth century and was surely the most popular. It is widely known as the 'tobacco leaf' design, however the leaves are possibly not those of the tobacco plant, but are as likely to be derived, possibly with some help from a European or Indian textile designer, from the thick, tropical, variegated-leaf foliage of Southern Asia and the Pacific. The flower shows every sign of being derived from two flowers (hibiscus and passion flower), but with a fullness which is reminiscent of the peonies of earlier decades.

Examples of this pattern vary from an 'all-over' design of leaves to one more sparsely decorated, and there are a number of minor variations, which include occasional figures and birds. It is found on garnitures, on dinner-services with a number of tureen types, and on tea-services with unusual, dumpy, cabbage-like teapots, and its decorative value has made it very highly prized among collectors, though both painting and porcelain are frequently heavy and its production stretched over four decades.

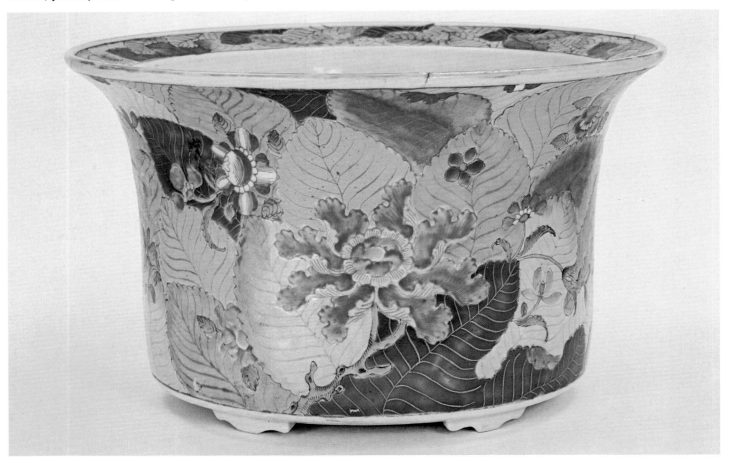

THE EXCHANGE OF CERAMIC IDEAS – EUROPEAN SHAPES

581

Urn

c 1790, height 16 in (40.5cm)

This massive urn, which would certainly never have been safe to lift by its handles, is made almost entirely of slabs of porcelain, and fitted with silver mounts. The body is of oblong octagonal shape, with sloping upper part and flat oval cover, and the whole is supported by four lions, showing every evidence of an attempt at realism, which may have been adapted from the arms of the Hon East India Company, in whose employ the original owner served.

The finial is in the form of a pomegranate, and the restored (but complete) handles are decorated with gilt raised floral mantling. The principle decoration is in blue enamel and gilding, and each side has an oval scene painted in sepia after a European original with a river estuary. Below, on *both* sides, is a lion mask spout.

The walls enclose an outer and inner compartment (one mask acting as a drain for the outer, and one for the inner) and on the further side is a small slotted aperture for filling the outer compartment. The lid is mounted in silver with the London hallmarks for 1796 and makers' name of T. Phipps and E. Robinson.

The outer compartment was probably used for hot water – in which case the original use of the urn may not have been for tea but for hot punch or even a type of gravy (using the same principle as an 'Argyll', then a popular gravy vessel in the form of a coffee-pot). The inspiration would appear to be from silver, for the shape and weight are strangely impractical in porcelain.

This urn was the property of William FitzHugh (born in 1757) who was a supercargo at Canton between 1776 and 1791, and a cousin of Thomas FitzHugh after whom the well-known style of porcelain was named, and it may have been brought back on his last journey. Up till 1975 it was still in the possession of the FitzHugh family when it was sold by Mr T. V. H. FitzHugh. One other example is known in a Portuguese collection.

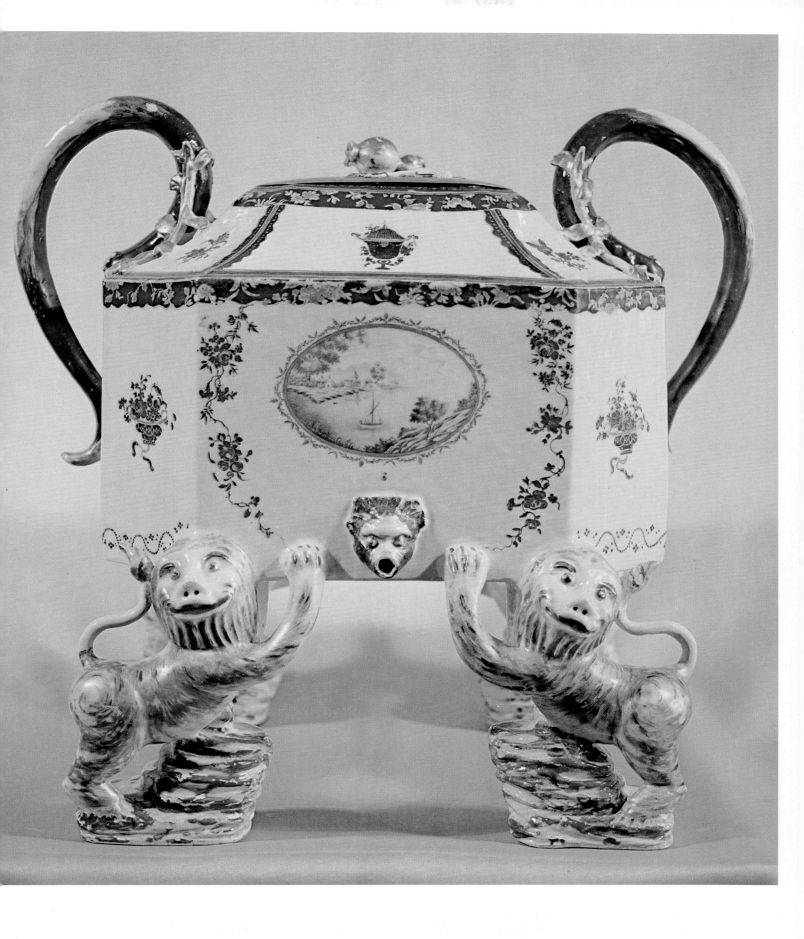

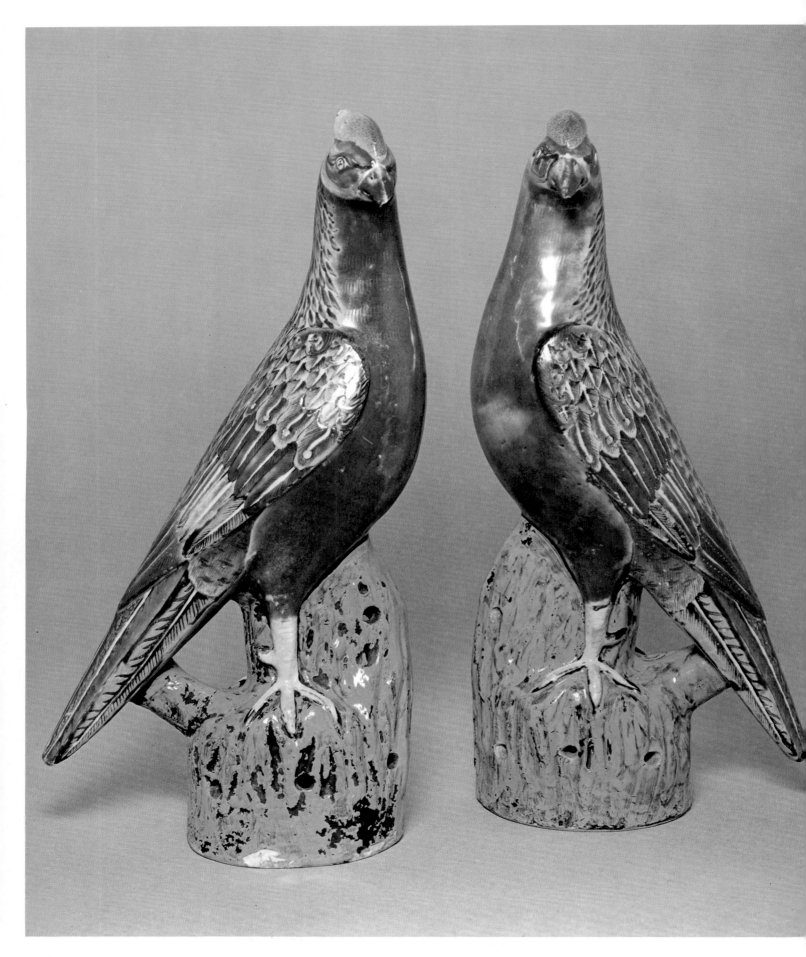

FIGURE MODELS

613
Pair of pheasants
c 1750–1770, height 14⅜ in (36.5 cm)

Standing alert, with heads turned respectively to right and left and perched on high rockwork bases which are pierced with small holes, and have projecting supports for the long tails. The breast and neck are enamelled in brilliant iron-red with down indicated in shaded gold, and the moulded wings and tail are in rich polychrome with overlapping feathers and plumes of puce, yellow, pink, deep green and sepia, touched with white and shaded with black. The heads are in rose-pink and blue with a stippled yellow crest, the black eyes ringed in red and yellow and the beaks red, the feet in yellow. On the bases a bright blue is applied over black.

Perhaps these birds are most akin to the Golden Pheasant, with its prevailing tints of red and yellow, which is found in the southern provinces of China. A familiar subject in 'bird and flower' paintings and in the decorative arts generally, the Chinese pheasant is a common emblem of beauty and good omen.

These pairs of pheasants with their continually-varied plumage painted in resplendent style are among the most ambitious and sumptuous of all the earlier models made for export, and with production evidently flourishing over several decades the number of surviving specimens is not small. The fanciful enamelling owes nothing to Europe in this instance and the modelling, like that of some other animal figures such as those of cockerels, for example, seems also to be wholly Chinese-inspired.

Other examples: Lady Lever Gallery, Port Sunlight, (Hobson, *Catalogue of Chinese Porcelain and Wedgwood Pottery*, pl 80, in colour); Clandon Park, near Guildford, England (National Trust), a number of models.

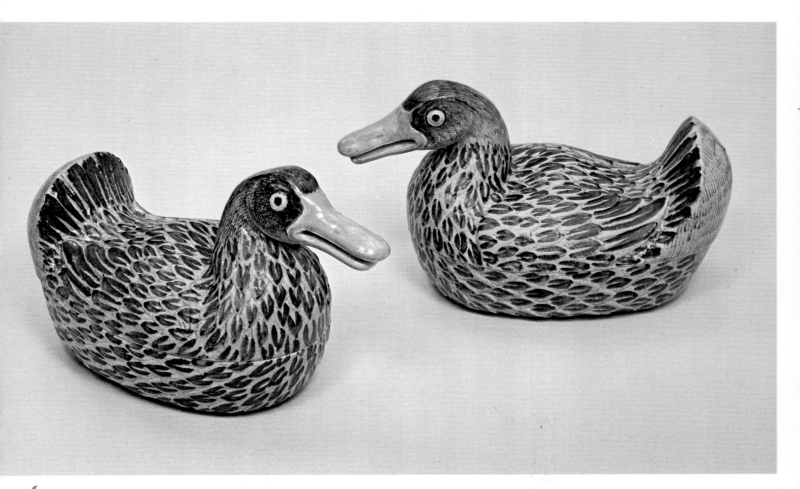

616
Pair of duck tureens
c 1760–1775, length (each) 5⅜ in (13.7 cm)

Tureens in the form of ducks swimming, the upper halves forming lids. The surface is moulded with feathers and other details, including the feet, extended along the underside. Enamelled all over directly on the 'biscuit' porcelain in violet-pink with detailing in black, the beaks and feet being in yellow. Unglazed interior.

Undoubtedly based on European originals: but while duck tureens were made at many porcelain and faience factories, the model for this attractive and lifelike pair has proved elusive.

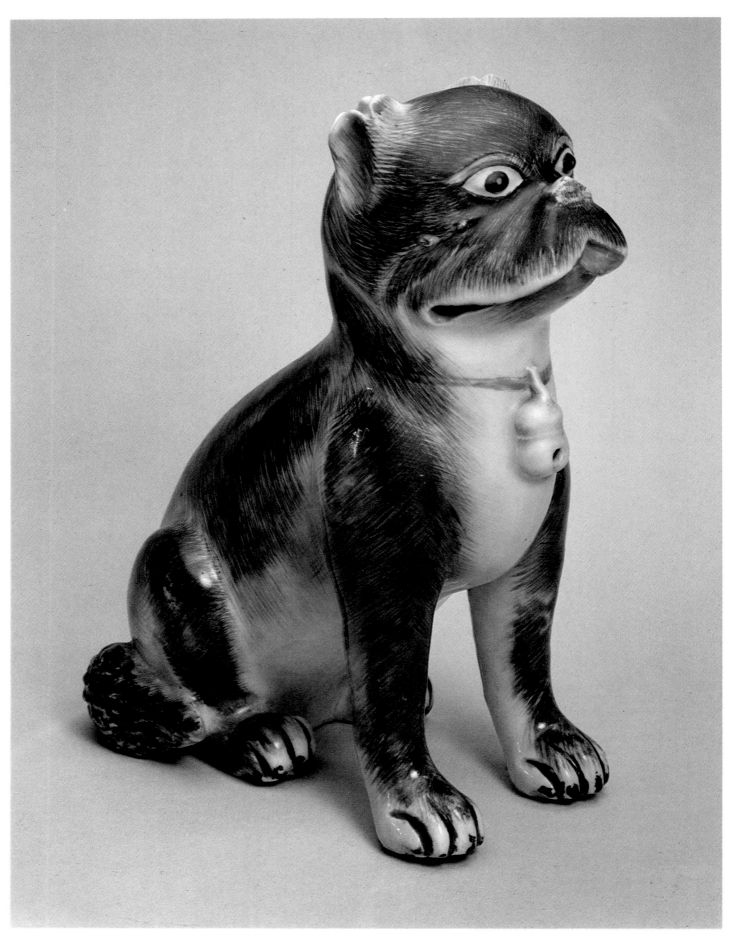

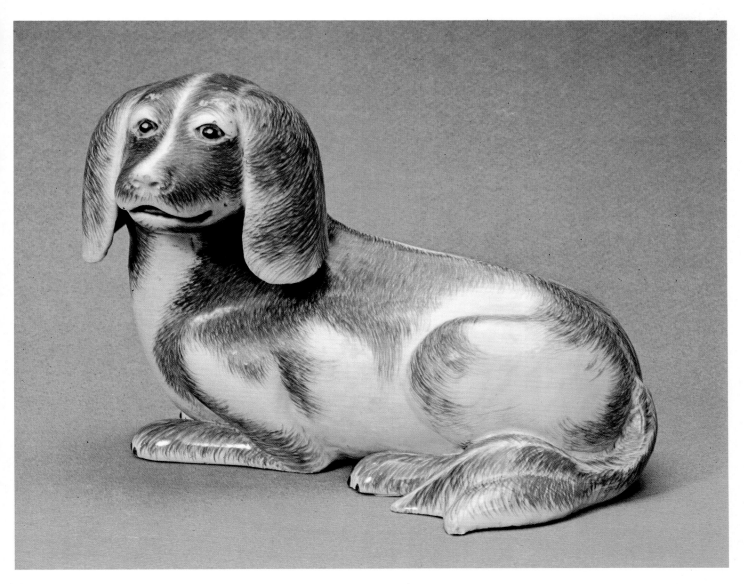

623
Pug dog
c 1750–1770, height 9½ in (24.1 cm)

Seated on its haunches, its short bushy tail curled to one side, the ears pinched upwards, the tongue projecting from the jaws. The coat is naturalistically indicated with areas of black enamelling; the pupils of the eyes are black with green centres, the tongue is crimson and the nose and mouth are in iron-red, as is the thin collar to which attaches a gilt bell applied in relief.

Although the pug is native to China, these very lifelike Chinese porcelain models were of course destined for export and are plainly based on European models that were supplied for the purpose. There can be little doubt of their parentage among the many versions of these dogs modelled and painted after the life at Meissen by Kaendler from *c* 1734 onwards (e.g. Rückert, Cats 1087–98, pls 268–69). Further models based largely on Kaendler's versions were made from the 1750s onwards in England at Chelsea, Bow, Derby and Longton Hall. The Chinese models themselves show a variety of types. As a rule they appear in pairs.

Other examples of pug dog models, very large (16½ in), J. Sparks (*Apollo*, Sept 1963, p iii); seated on all fours, Onassis collection (Beurdeley, Cat 196); scratching an ear, Ionides collection (Rienaecker, 'Fantasies of Chinese Ceramic Art', *Country Life Annual*, 1956, fig 10).

622
Spaniel
c 1750–1770, length 9 in (22.9 cm)

Recumbent with head erect and turned, with short muzzle and long ears, the bushy tail curling round the flank. The long coat is finely enamelled with patches of sepia-brown hair leaving areas of white glaze on the body, neck, spine and head; the tongue and eyes are crimson, the pupils black with green centres. Hollow model, with an oval aperture in the unglazed base.

Perhaps the most attractive of all the Chinese models of dogs, this small, long-haired and long-eared breed is widely supposed to have been popularized in England during the reign of Charles II (1660–85). Like the pug dog, the King Charles spaniel was a result of interbreeding with a type brought from China: it is sometimes said to have been introduced direct as an oriental gift to the monarch but this seems in fact to have occurred a century or more earlier, perhaps through the medium of the Portuguese. Of the various Chinese versions, the red and white markings in this case agree with the description of the Blenheim variety.

Standing horse
Late 18th century, length 11 in (28.0 cm)

A chestnut (?)mare standing in a patient attitude with long mane combed down over the right side of the neck and a tuft falling over the forehead, the ears pricked forward, the long tail falling almost to the ground. The body is wholly covered with skilfully-shaded enamels in chestnut tones with darker tints representing the coat; the mane and tail, which are separately moulded and applied, being in rather salmon-pink tones streaked with black and with white, and bearing red tassels or markers. The hooves, mouth and eye areas are finely shaded with grey, with white eyelashes. On the front right upper leg is a spot or wart. The feet were drilled to take supporting pins; and on the underside is a square unglazed patch to take a firing support.

This model is one of a series of porcelain horses apparently inspired by the paintings of Lang Shih-ning (G. Castiglione), the Jesuit artist at the Imperial Court who produced many scrolls depicting horses of the Imperial stud. A series of such paintings preserved in the National Palace Museum, Taipei, entitled 'Five prize steeds', includes one of a chestnut with white mane named *Hung Yü Tso* and dated 1743 AD which is similar, although not the same as the present model (*The Selected Paintings of Lang Shih-ning*, II (Hong Kong, 1971), series 5, no 6). This also shows a weal on its right leg, although the red tassel is absent, as are the darker streaks in the coat.

A few other such porcelain horses are known: all show the same refinement of modelling particularly as regards the legs and are painted in an especially fine and naturalistic style, employing rather dry enamels.

From the Goldschmidt collection. It then possessed a rectangular base.

Other examples of similar models: two in the Victoria & Albert Museum, still with their flat, rectangular, green-enamelled bases, which were evidently added in the late nineteenth or early twentieth century.

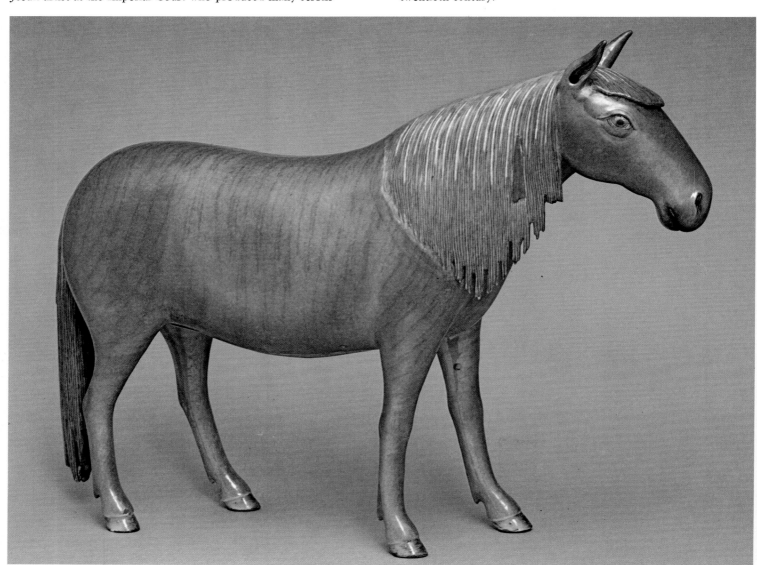

627

Ox-head tureen
c 1750–1755, length 14½ in (37.6 cm)

Modelled in naturalistic style as the head of an ox, the upper half of which forms a detachable cover. The projecting open jaw, palate and tongue within are enamelled in salmon-pink and rose-purple, the upper part having a brown muzzle with pierced nostrils penetrating to the interior. The two curving, ridged horns are coloured in black, brown and yellow, and the wide-open eyes have black pupils ringed in gilt and with red veining. On both parts the hide is represented in mustard-yellow with soufflé reddish-brown areas; a brown star is set between the horns; and

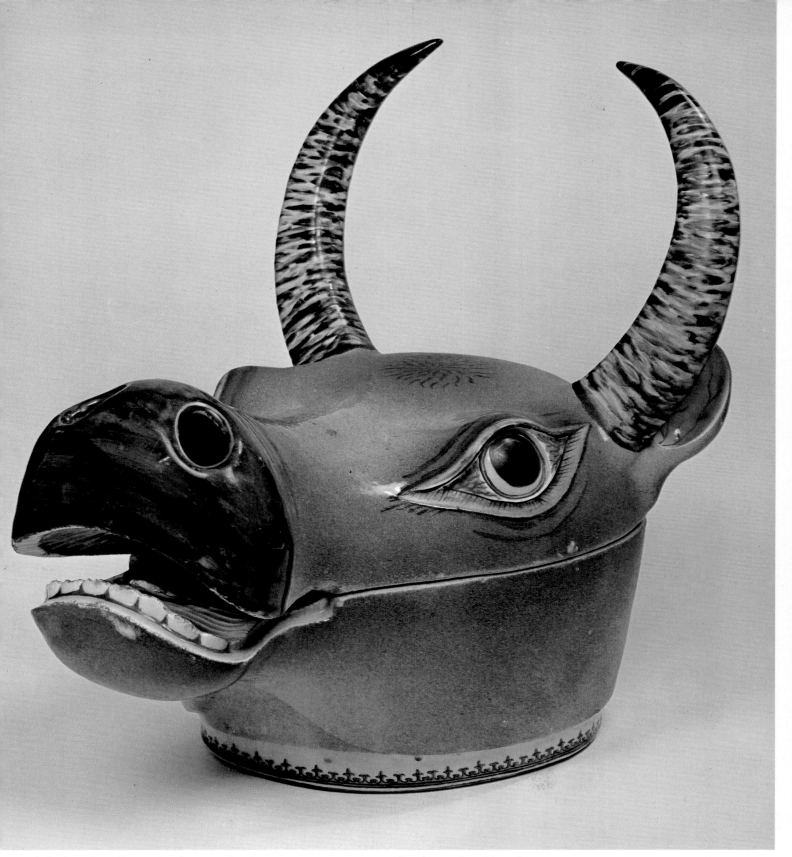

round the base is a gilt spearhead-pattern border.

 This is a particularly striking model. No Western equivalent to such a tureen has yet been traced. Significantly, however, an example is known with supposedly matching stand and decorated with scattered flower sprays painted much in the manner of Strasbourg faience (Sotheby Parke Bernet, New York, 16

October 1969). Also of interest is another tureen with similar colouring to no 627, which displays on the head a plain-ground medallion with a scene of a courtier and a lady (Beurdeley, pl I, in colour; no 277). Apparently *en suite* with this is a boar's head tureen, accompanied by its own matching stand (Sotheby's, 3 July 1973, lot 262). The ears have been sensitively restored.

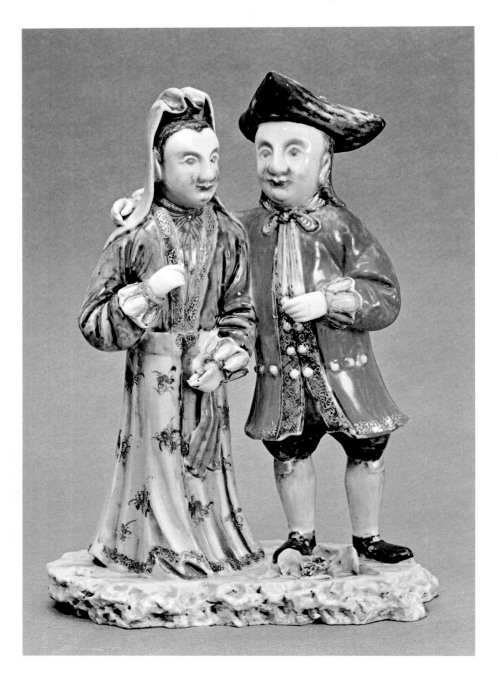

647
Dutchman and lady
c 1770–1790, height 9 in (22.8 cm)

Standing together on a roughly-modelled rockwork base, the man's arm encircling the woman's shoulders. In her left hand is a scarf. He is dressed in a red frock coat with black and gold border, a knotted scarf, black trousers and blue hose, and wears a black tricorne hat. She wears a purple jacket with flowered green skirt, and a pale blue mantle over her head and shoulders. The cheeks of both are rouged with crimson-pink.

Like other figures represented in this Collection this group has been described as 'Governor Duff and his Wife', apparently with little justification. The group exists in several versions and the existence of the same model in undecorated white porcelain (for example, in the National Museum of Ireland, Dublin) is a warning that such models could have been decorated in Europe, although this does not seem to be the case here. The spotted painting of the faces is probably an attempt to reproduce the stippled effect of some European flesh painting or perhaps mezzo-tint.